FOUNDATIONS IN COMIC BOOK ART

FOUNDATIONS IN
COMIC BOOK ART

Fundamental Tools and Techniques for Sequential Artists

JOHN PAUL LOWE

WATSON GUPTILL PUBLICATIONS
Berkeley

SCAD.®
Creative Essentials

THE SCAD CREATIVE ESSENTIALS SERIES

The SCAD Creative Essentials series is a collaboration between Watson Guptill Publications and the Savannah College of Art and Design (SCAD), developed to deliver definitive instruction in art and design from the university's expert faculty and staff to aspiring artists and creative professionals.

Published in the United States by Watson-Guptill Publications, an imprint of the Crown Publishing Group, a division of Random House LLC, a Penguin Random House Company, New York.
www.crownpublishing.com
www.watsonguptill.com

WATSON-GUPTILL and the WG and Horse designs are registered trademarks of Random House LLC

Library of Congress Cataloging-in-Publication Data

Lowe, John (John Paul), author.
Foundations in comic book art : fundamental tools and techniques for sequential artists / John Paul Lowe. — First Edition.
pages cm. — (SCAD creative essentials)
1. Comic books, strips, etc.—Technique. I. Title.
NC1764.L68 2014
741.5'1—dc23
2013046051

Trade Paperback ISBN: 978-0-7704-3696-4
eBook ISBN: 978-0-8041-3713-3

Printed in China

Interior design: Kenneth Crossland, Katy Brown, and Anitra Alcantara
Cover design: Katy Brown
Front cover art: Jorge Corona
Back cover art: Drew Wieng (top), Zhenya Okun (bottom)

10 9 8 7

First Edition

DEDICATION

This book is dedicated to:

My mom, for encouraging me to pursue whatever interested me.

My children—Jonah, Koji, Atticus, and Bete—for inspiring me.

My teachers, for sharing their knowledge with me.

My students, for teaching me.

My wife, Erin, for putting up with me.

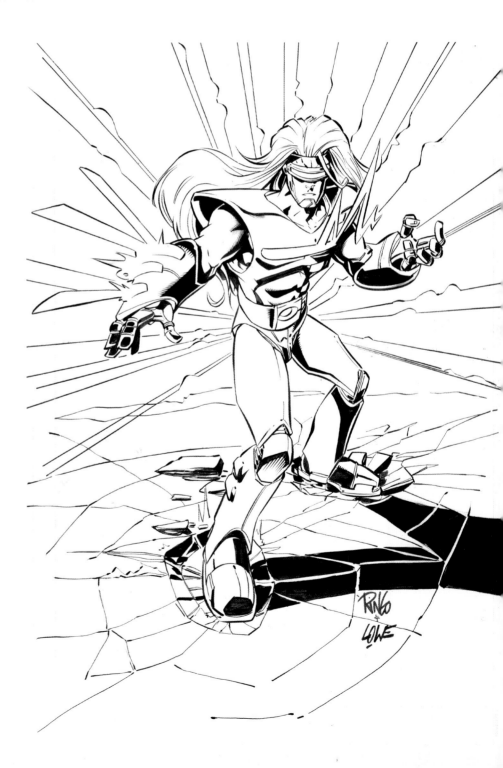

CONTENTS

FOREWORD

One of the saddest lessons you will learn when you go to art school is that your art is not very good. One day in sophomore year you will look down at your Dali-inspired colored pencil drawing of anthropomorphic lizards, and you won't be able to ignore it any longer. You'll look up at your professor and see it in her eyes: she thinks you're a bad artist. She thinks you're a bad artist, and she doesn't think you're ever going to get better.

"Very creative," she'll say.

"Thanks," you'll say.

John Lowe thinks you can get better. In fact, he's sure you can get better. He's sure you can get *good*.

This is what makes John Lowe a great teacher and an unusual one. If you are his student, he is interested in you and he is interested in your art. He finds out what your goals are, and he doesn't let you forget them. He finds out what your comfort zone is, and he jabs and teases you out of it. He finds out what tools you're used to using, and he doesn't let you use them anymore. He finds out how much homework you're used to doing, and he assigns twice as much. He takes

artwork you were up all night working on and tells you to change everything. He tells you to change everything, and you squawk in disbelief, and John laughs and say, "Nothing's precious."

And it's true: nothing you put on paper is precious. You have something else that's precious, and it's something John will find for you when you can't find it yourself anymore. It's why you started drawing in the first place. It's in your hand, your eyes, your heart. Don't lose it. Don't let it get away.

Eleanor Davis
SCAD Alumna

Eleanor Davis a cartoonist and illustrator. She created the graphic novels The Secret Science Alliance *and* The Copycat Crook. *Her work has been recognized by the Society of Illustrators and Print. She has won the Theodor Seuss Geisel Honor and the Russ Manning Award. Originally from Arizona, Davis now lives in Georgia.*

PREFACE

I decided to become a comic book artist when I was in the seventh grade. I told everyone I knew about my career decision, whether they asked or not. I wasn't bragging—I knew that making my intent public would make me less likely to back out of it.

I earned a degree in fine art from the University of Tennessee, Knoxville. I had several exceptional professors who taught me how to draw from observation. If comics only required the ability to draw from life, I would have felt comfortable with the portfolio that I took to the offices of Marvel and DC comics the year after I graduated.

However, comic art requires additional skills, many of them. A comic book artist is required to demonstrate an understanding of perspective, composition, page and panel design, acting, and staging. A comic book artist must be able to *create* things that don't exist, which means he or she has to have the ability to make constructive (instead of observational) drawings. My college training didn't prepare me for that.

Fortunately, my drawing skills helped me land a position as an inking assistant for one of my favorite inkers Josef (Joe) Rubenstein. I didn't do much more than fill in large areas of black ink, and cut Zip-a-tone patterns out, but I got to see an amazing inker working on *real comic pages* every day. Joe was also kind enough to critique the inking sample pages I was working on at night. I was inking for DC Comics within a year.

Throughout the 1990s I worked with some of the most talented comic artists in the industry, and over the course of that decade they helped me develop my drawing and storytelling skills.

I began working as a sequential art professor at the Savannah College of Art and Design (SCAD) in 2002.

SCAD became my home, and teaching became my passion. Creating classes and lectures, and mapping out syllabi and lesson plans, forced me to structure my thoughts. I love teaching. It's the most exciting and rewarding job I've ever had. I always look forward to entering the classroom and seeing the work my students produce.

When I began writing, I imagined the book my students (and my younger self) would want to discover at the library. When choosing *what* to cover, I considered what I believe to be essential rules for drawing. If it wasn't essential, I removed it.

Learning to draw requires you to learn to *see* differently. And each of us sees things in a unique way. The chapters in this book are arranged sequentially and should be followed in order. The first chapters deal with learning how to see and interpret the world around you (observational techniques), and how to create things from your imagination (constructive techniques).

The latter chapters are devoted exclusively to producing comic book pages. You will learn how to use tools, techniques, and software to create comic pages quickly. Speed is important. Comic artists, on average, need to produce at least one finished comic page per day.

The most rewarding part of teaching is watching young artists develop their artistic *voices*. That's another reason I avoided writing a book that centered on specific techniques. All too often, students who rely on learning how to create artwork based on a very rigid technical approach developed by another artist, produce homogenous pieces of art. I like idiosyncrasies. This book contains tried and true *principles* that will allow you to develop an artistic style that belongs to you.

I look forward to seeing what you produce.

1

ANYONE CAN DRAW

The Two D's: Desire and Discipline

Desire is the easy part. Almost everyone wants to excel at something: sports, music, writing, acting, dancing, or creating art. And the fact of the matter is that all people can succeed if they dedicate themselves to intelligent study and consistent practice. That is what separates those who will eventually succeed in their chosen field from the dilettantes.

Most people don't realize how many skills a successful sequential artist has to master. A thorough knowledge of anatomy and figure drawing, composition, design (both within a panel and in arranging several panels on a page), storytelling, shot selection, and perspective is essential.

As a comic artist, if you work with a writer, you are required to draw anything that he or she can imagine: a crowded New York City street, a coliseum filled with spectators and participants, Berlin during World War II, and so on. If something doesn't exist, such as a planet no one has seen before, you must create that world, its buildings and vehicles, and its inhabitants. I realize this sounds intimidating, but when you have honed your talent, it's an exciting and enjoyable challenge.

Every artist has the same hurdles to overcome. We have all struggled with feelings of ineptitude and frustration. Thoughts such as "My human figures never look right," "I'll never learn perspective," "This is just too hard," "I'm not fast enough," "They are better than me," and "I don't have a chance" have all gone through everyone's head at one point or another. I've certainly had all of those thoughts. However, dedication and daily practice will quell those fears.

I have taught sequential art for over a decade and have had the pleasure of seeing former students go on to successful careers, win awards, create their own comic characters, and have their creations optioned for film and television. Teaching confirmed a suspicion I've always held: talent is overrated. Sure, some students came in and displayed such artistic facility that I knew from the time they turned in their first assignments that they would be working professionally in a short time. But those were the (very) rare exceptions. The majority of students I teach begin at the same skill level. They like drawing and have filled up sketchbooks with their favorite characters, but they don't know how to draw two or more characters interacting, how to place those characters in an environment by using perspective, how to portray subtle emotions, or how to pace a story. That's why they came to college to study comics.

The determining factor in a student's success is his or her willingness to work consistently and intelligently. Successful students listen to constructive criticism, study books to improve their storytelling and drawing skills, gain the ability to analyze their work objectively, and, perhaps most important, draw daily.

If you are considering a career in comics, the most important question to ask yourself is "Do I love drawing and telling stories?" Every comic artist I know works at his or her drafting table for at least eight hours a day. Most of them put in more hours than that. They do it because they love it and wouldn't consider doing anything else.

Necessary Materials

Learning to draw well requires you to invest time, not money. I love that. If you own a pencil and some printer paper, you're good to go. However, there are some standard drawing tools that most comic artists use daily.

PENCILS

There is a wide assortment of graphite drawing pencils available. These pencils are typically sold in a range from 6H to 8B. The H series denotes a hard lead; the pencil lead becomes firmer and produces a lighter line as the numbers increase. Conversely, the B series signifies a softer lead and produces a darker line as the numbers increase.

Since comic art is primarily linear, it isn't necessary to purchase a full range of pencils. A standard #2 pencil uses an HB lead that is great for preliminary drawings or sketching, but has a tendency to smudge if you run your hand over the drawing. Many artists prefer to sketch or do their layouts with an HB (most school pencils are HB) or 2B pencil and use a 2H pencil for their final drawings.

The shading for the drawing below was done twice: once with an HB pencil (below, top) and once with a 2H pencil (below, bottom).

ERASERS

A kneaded eraser is the best option when you draw. It is pliable, it doesn't leave any residue on the page, and it will not adversely affect the surface of any paper. If you need to erase a large area, such as the entire page after you have inked it and want to remove the remaining pencil lines, use a large white rubber eraser.

PAPER

You should not invest in high-quality paper until you start producing finished pages. Buy a ream (500 sheets) of printer paper and an inexpensive sketchbook. I prefer a 9-inch by 12-inch spiral-bound sketchbook because you don't have to hold it open like a book, which can be irritating when sketching.

An **HB** pencil (most standard #2 school pencils are HB) is a great sketching tool, but the lead is soft and it often smudges.

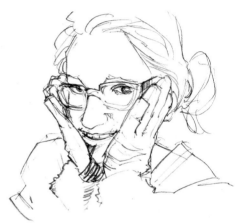

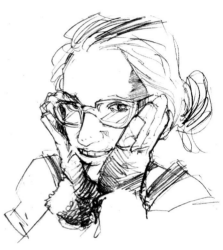

A **2H** pencil rarely smudges.

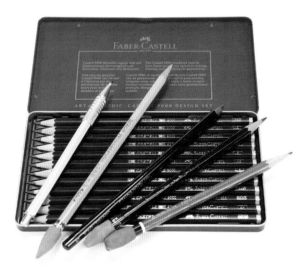

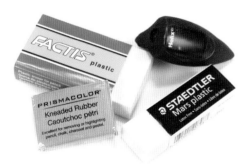

Pencil companies are abundant. You can buy mechanical pencils (no sharpening required) that hold a 0.3-, 0.5-, 0.7-, or 0.9-mm-diameter piece of lead. You can purchase pencil sets if you want a range of leads from firm to soft. But really, all you need is an everyday school pencil and a handheld pencil sharpener.

A kneaded eraser is wrapped in plastic and looks and feels like putty. You can purchase white rubber erasers in large and small sizes. The large size is great for erasing pages of 11-inch by 17-inch original art. The Helix eraser pictured here houses a pencil sharpener; that's pretty nifty.

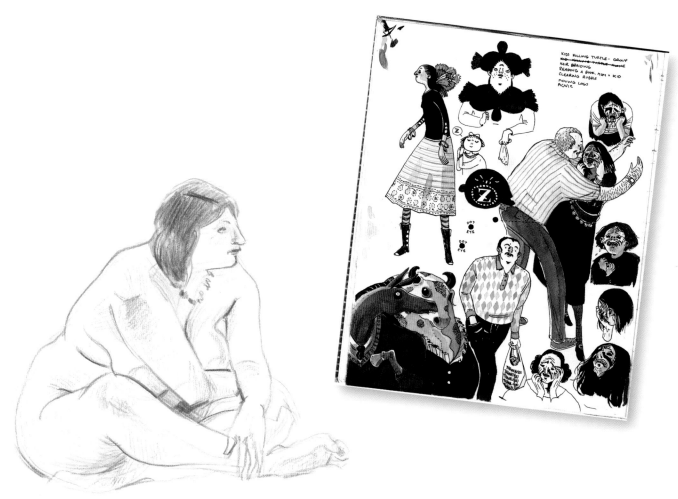

These drawings were created with a variety of materials: pencils and colored pencils, watercolor, ink and ink wash, quill nibs and brushes, and ink dyes.

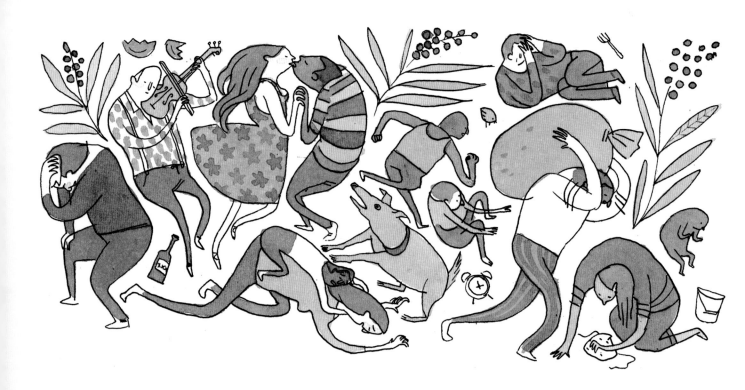

DRAWING OBJECTS FROM MEMORY

This is one of the best exercises for any aspiring comic artist. It isn't complicated, and thanks to the Internet, you have an unlimited resource for interesting things to draw.

You'll need a blue pencil, a ballpoint pen, and a timer of some sort for this exercise.

1. Choose a photograph of an interesting object.

2. Look at it for *one minute* and try to commit as much information to memory as possible.

3. Turn away from the computer or minimize the window the object is displayed in and try to draw the object in blue pencil in *two minutes*.

4. Look at the object again and spend the next *two minutes* making an observational drawing in ballpoint pen on top of the pencil drawing. If you made mistakes in your initial sketch (and you will), correct them with the pen.

This exercise will improve your visual memory and make you observe the world around you more closely. Learning to draw well requires careful observation and analysis.

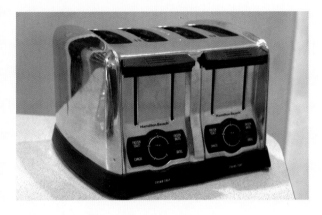

Look at this toaster and try to memorize its basic shapes and the placement of specific features.

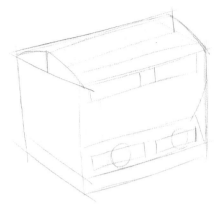

Sketch in the basic shapes first.

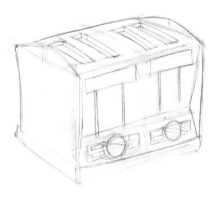

Place the specific features, as you remember them, on top of the basic shapes you drew.

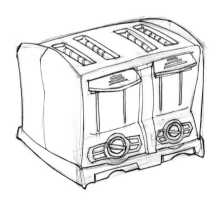

Look at the object again and use a ballpoint pen to draw its details from observation. If you remembered something incorrectly, adjust it using the pen.

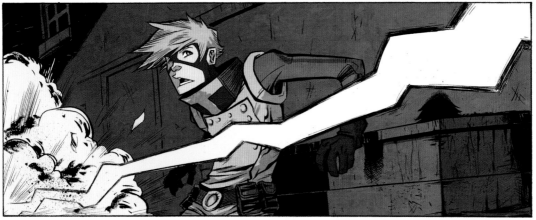
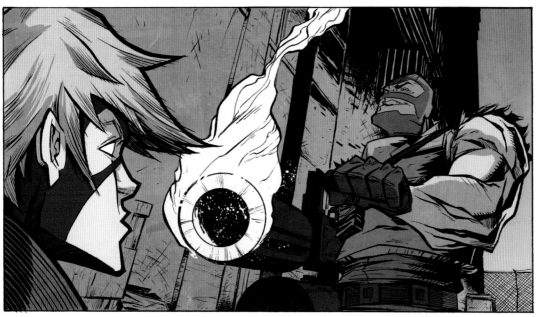

A lot of technical skills are necessary to create comic pages, but when you have mastered those skills, every day is more like play than work. The skills and techniques displayed in these examples include an understanding of figure drawing, inking, perspective, visual pacing, page layout, and composition.

2

LEARNING TO SEE

Drawing Straight Lines

The old adage "I can't even draw a straight line" is erroneous. Anyone can do this with practice, and learning to draw straight lines without the aid of a ruler is worth the investment in practice time. It will make your drawings look more confident, save you a lot of time, and allow you to draw freehand perspective grids (I'll elaborate on this in chapter 3). Drawing long straight lines requires you to draw by using your arm, and to do that you must hold the pencil differently.

FREEHAND DRAWING

Make sure to clear everything off the drawing surface before you begin.

Place your elbow on the table and hold the pencil in an upright position, rotating your hand so that your palm is resting on the paper; this positioning prevents you from using your fingers or wrist, which will cause your line to curve, when you draw. Now, using your elbow as a fulcrum, draw a line across the paper.

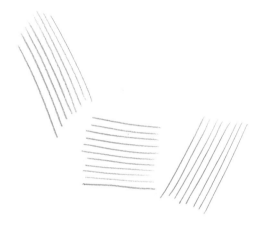

After you get comfortable drawing straight lines, draw a series of equidistant parallel, straight lines. Draw at least ten lines per group.

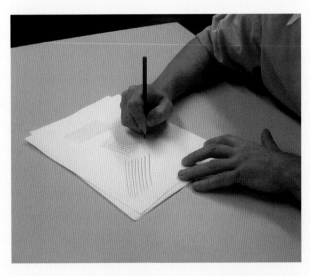

Everyone has a natural stroke. When I draw freehand straight lines, my arm moves from left to right at a 45-degree angle. Some of my students find that their natural stroke moves from top to bottom or vice versa. Find your natural stroke; you can always move the paper around to accommodate it.

You should also practice drawing straight lines that connect two points. Keep doing this, varying the distance between the points (some can be short distances, but others should be much longer), until you can draw straight lines through them at will.

Seeing Forms

Artists must train themselves to see the simple forms of any object first and to recognize that anything they see can be placed within cubes, spheres, cylinders, or cones.

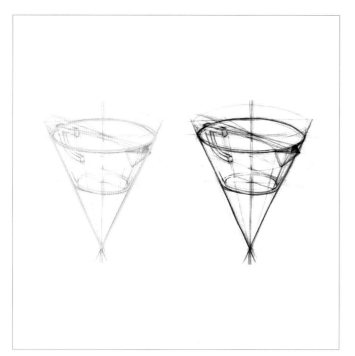

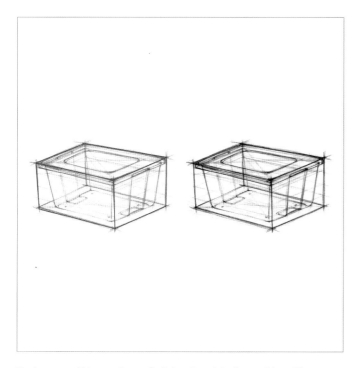

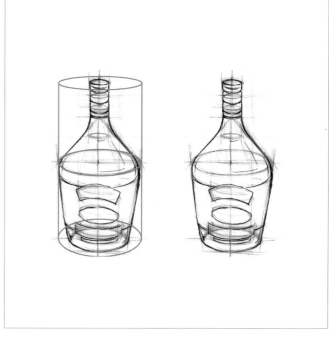

Train yourself to see the underlying form(s) of any object. The underlying forms of all these objects have been highlighted. Identifying the basic shape or combination of shapes in the object you are sketching is a fundamental principle of good drawing.

Complicated objects are composed of various combinations of these basic shapes. Before you draw anything from observation, study your subject and ask yourself, "What is the underlying shape, or shapes, of the thing I'm drawing?"

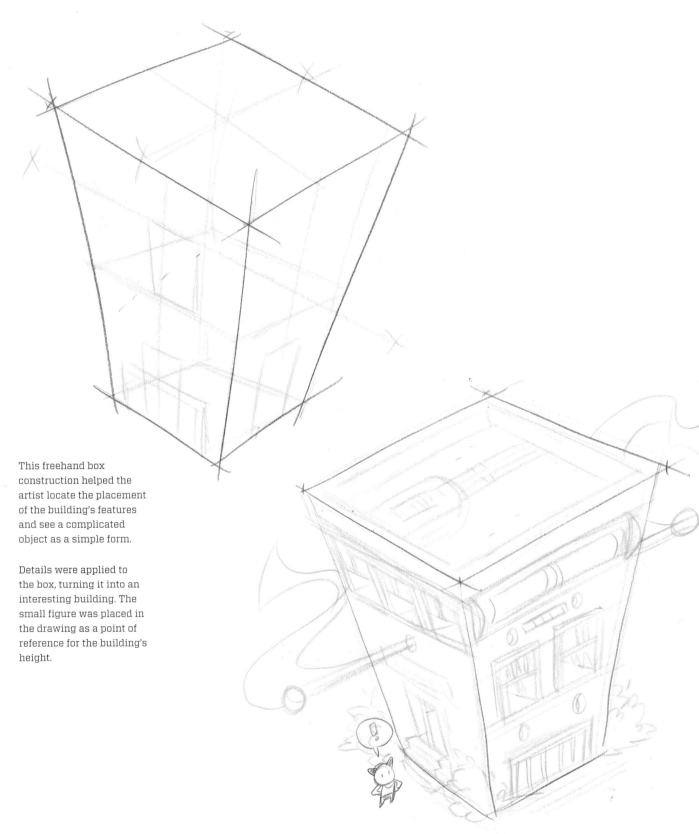

This freehand box construction helped the artist locate the placement of the building's features and see a complicated object as a simple form.

Details were applied to the box, turning it into an interesting building. The small figure was placed in the drawing as a point of reference for the building's height.

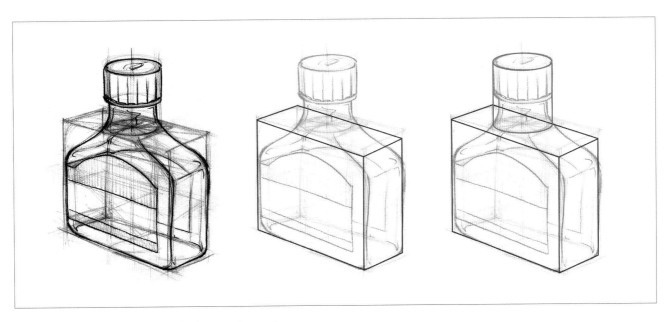

This bottle is composed of two basic shapes: a box and a cylinder. The majority of the bottle is found within a box. The stem and cap are located within a cylinder, which houses two sets of ellipses (circles drawn in perspective).

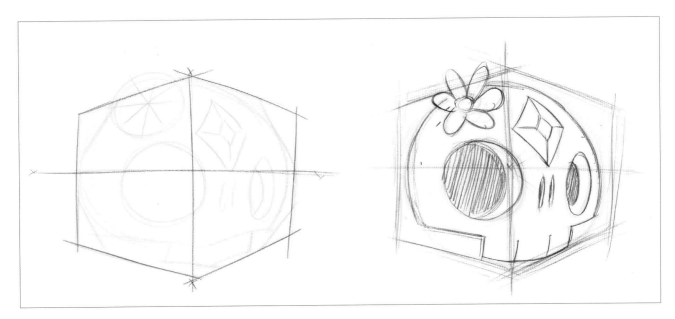

This box helped the artist visualize how much space the skull's shape takes up. The drawing begins with the placement of general shapes. By adding details and altering the lines of the basic shapes the artist makes this an interesting drawing.

Contour Drawings

Contour lines, especially in comic book art, play a crucial role in the way the viewer perceives the surface of a figure or object. They map out the surface of an object that would otherwise look flat and create volume within a linear drawing.

Look at some shapes. It's hard to see them as anything other than flat patterns, as if someone had outlined a silhouette. But you can create several unique interpretations of those basic shapes by drawing different directional lines across them, manipulating their surfaces.

Contour drawing also makes an artist aware of the way subtle shifts in lines can create significant shifts in the way an object is perceived. When you are practicing contour drawings, see if you can "feel" the object you are drawing—imagine the sensation of running your pencil along the surface of the object. Then draw through it to the other side.

It's easiest to explain this with a simple example. A football has two stripes that wrap around it. When you make a contour drawing, you want to feel your way around those stripes. Don't just draw a line on the surface; draw an ellipse all the way through the football as if you can see through the material to the other side. It takes a little practice, but when you start perceiving things this way, your drawings will improve quickly.

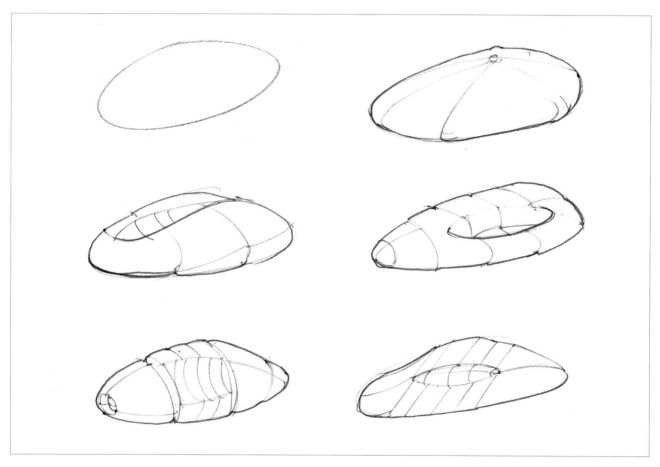

Each of these complex shapes began as a simple freehand ellipse drawing. The direction in which the lines are drawn modifies the way the surface is perceived. Contour lines transform *shapes* into *forms*.

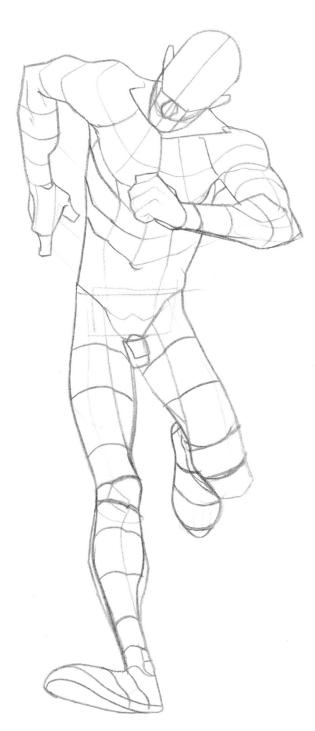

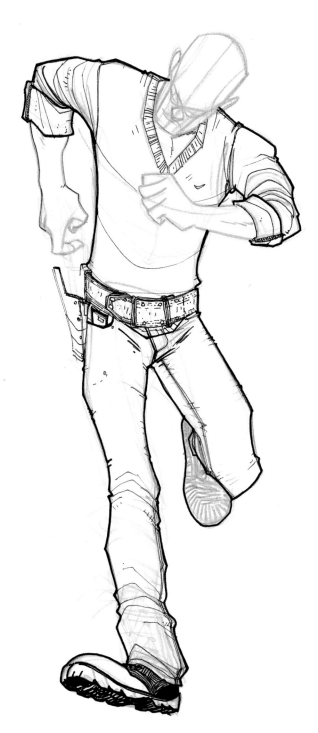

The contour lines on this figure help you picture the complex forms of an organic figure.

The contour lines also help you place clothing and folds correctly.

DEFINING VOLUME THROUGH LINE

Draw some generic shapes and then draw contour lines within those shapes.

Modify one shape several times by using only contour lines. Trace over photographs with contour lines. This will help you gain a better understanding of the planes and surfaces of any figures, faces, or objects you draw.

Study the example below. The basic shapes were identified first and drawn in blue pencil. This approach allows you to concentrate initially on basic shape relationships to help you see proportions correctly. Contour lines were added next to give volume and detail to the drawing. Then a ballpoint pen was used to identify the contours of the subject.

I chose to draw this bottle because it is made up of a combination of interesting shapes.

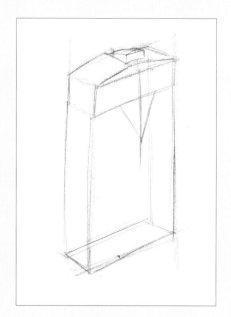

I began by drawing the most basic shapes in blue pencil with freehand straight lines. These shapes are rectangles and triangles.

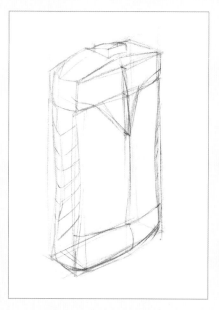

I then added details, focusing on the bottle's contour lines.

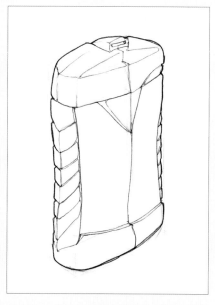

I used a ballpoint pen for the final drawing, using the underlying blue pencil lines as a guide. The exterior line is thicker than the interior lines; this helps the viewer read the interior lines as details within the bottle.

Drawing Multiple Objects

When you have become adept at seeing and drawing the underlying forms of any subject you choose to draw, and at adding specific details on top of those shapes, you're ready to practice drawing multiple objects. A still life will train you to draw a group of objects and make them proportionaly to one another. Here are two techniques to help you make a good observational drawing:

- *Plumb lines.* Plumb lines are a series of straight vertical or horizontal lines that are used to help you determine where objects align with one another. Hold your pencil or another straight object such as a skewer at arm's length to establish the size relationships and angles of the objects you are drawing. You can also apply this technique to photographs.

- *Quadrants.* When working from a photograph like in the example below, draw a rectangle around the subjects you want to draw and draw a vertical line and a horizontal line through the rectangle's midpoints. The four quadrants this creates help you place the objects more accurately within your drawing. If you are working from life, make a viewfinder by cutting a rectangle out of a sheet of printer paper discarding this rectangle and putting marks on the vertical and horizontal midpoints of this frame. If you feel very ambitious, tape strings to the midpoint marks, creating four quadrants within the viewfinder.

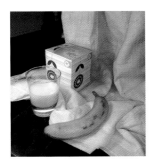 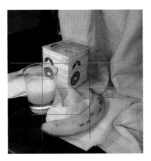

Creating a still life is easy to do: just gather a few things from around the house.

PLUMB LINES
The blue lines are the horizontal plumb lines. The red lines are vertical plumb lines. I've used the tissue box as a point of reference. Its left edge aligns with the middle of the glass and with the end of the banana. Its right edge touches the stem of the banana and reveals a small negative space between the stem and the banana's body. The drapery edge hits the tissue box on its left-hand side.

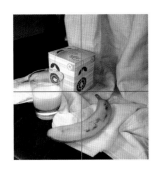

QUADRANTS
If you were drawing the objects pictured here, ask yourself these questions about the placement of the objects in the quadrants: How high is the box in relation to the banana? Where does the drapery intersect the box? What is angle of the banana?

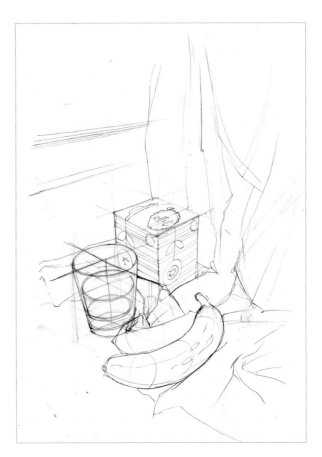

This is the final pencil sketch. You can see that it has employed plumb lines and quadrants and utilized contour lines to better represent the shape of the banana.

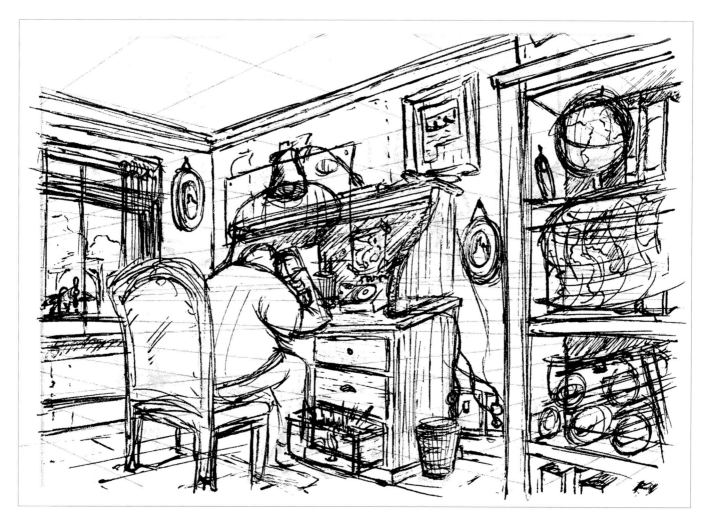

This complex interior space began as a series of boxes.

As your drawing skills improve and you begin to commit techniques to memory, you will start to create interesting pictures filtered through your unique creative lens. Everything shown in this illustration (the bicycle, the various building shapes and facades, the van, etc.) seems correct, even though they are drawn in a style that would be a categorized more as "cartoony" than "realistic."

SUMMER · IS · HERE · · PITS · ARE · SWEATY · · NOT · JUST · PALMS · AND · AND I'VE BEEN THINKING ABOUT GOING ON...

IMAGINARY DATES with my PRETEND BOYFRIEND

by J. Sorese · SUMMER 2012

3
PERSPECTIVE BASICS

How to Divide a Square

It sounds silly, but the square is the most valuable and necessary shape for any type of technical drawing (environments, props, vehicles, etc.). If you can train yourself to draw one perfect square, you can place and multiply additional perfect squares infinitely. This is an invaluable tool for perspective drawing.

1. A square is composed of four equidistant sides, and you can locate its vertical and horizontal midpoints by drawing an X through it and then drawing a horizontal and vertical line through the center of this X.

2. You can also locate smaller squares inside it by placing a single point on the X and drawing a horizontal and vertical line from this point, parallel to the original sides of the square. Complete the square. Each time one of the new lines connects with the X's line, change direction, until you end back at your initial point.

3. If you want to make a larger square, simply extend the X beyond the initial square, locate a point, and draw parallel lines.

1.

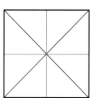

2.

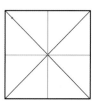
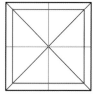

3.

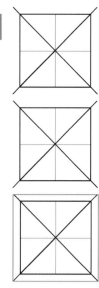

HOW TO CREATE ADDITIONAL SQUARES

1. Once you have one perfect square, you can create other squares around it. To add a square on the right, for example, extend the top and bottom lines of the initial square and draw a line from the top left corner through the vertical midpoint on the right side of the square, until it intersects with the newly extended line.

2. When it touches this point, draw a vertical line from this point, parallel to the side of the initial square. You've just created a second perfect square. You can repeat this process infinitely.

3. You can also create additional squares above or below the initial square with this technique.

HOW TO CREATE ADDITIONAL RECTANGLES

1. Locate a smaller area within the left rectangle.

2. Draw a line from the upper corner of the smaller shape through the midpoint until it touches the bottom line of the right rectangle. Draw a perpendicular line up to the top line.

3. You now have a smaller, mirrored shape.

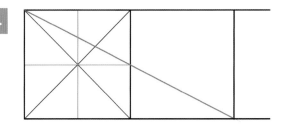

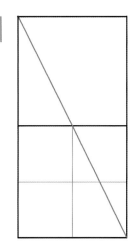

Creating Symmetrical Curves within Two Squares

The ability to place symmetrical curves within two squares is extremely beneficial when you are working with perspective drawing, and it isn't very hard. Almost every manmade structure incorporates symmetrical design.

1. Look at the two squares in this illustration. I've placed a simple curve in the left-hand square. I know the curve begins at the bottom left corner of the square on the left, and so a symmetrical curve will end at the bottom right corner of the square on the right. Locating one additional point on the curve will help me mirror this curve.

2. Place a dot on the curve.

3. Draw a vertical line through the dot. This creates two sections within the square.

4. Find the midpoint by locating an X within the new section you just created. Draw a line from the upper corner of the new section through the midpoint between the two squares until it touches the lower horizontal line.

5. Draw a horizontal line, starting on the first dot and extending to the right until it touches the new vertical line. Mark it with a new dot.

6. This new dot will help you draw a mirrored curve within the right-hand square. Start your line at the midpoint (the point on the top left-hand side of the right section), draw through the point you mirrored, and continue the curved line until you touch the bottom right-hand corner of the right section.

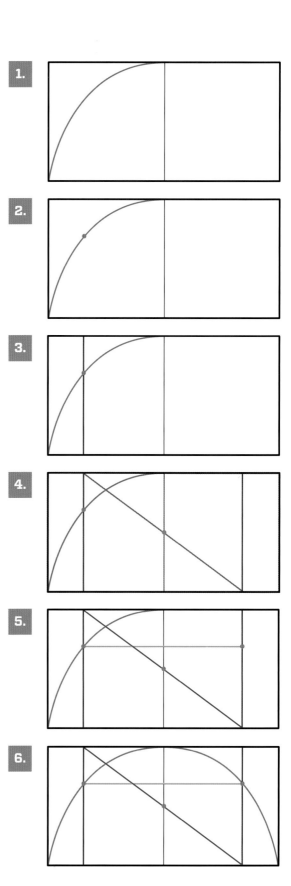

The Cube Method

A square placed in perspective is a cube, and if you can learn to recognize and draw accurate cubes (think of them as boxes with equal sides), you can draw any object, vehicle, or environment quickly and easily and place it in a perspective drawing.

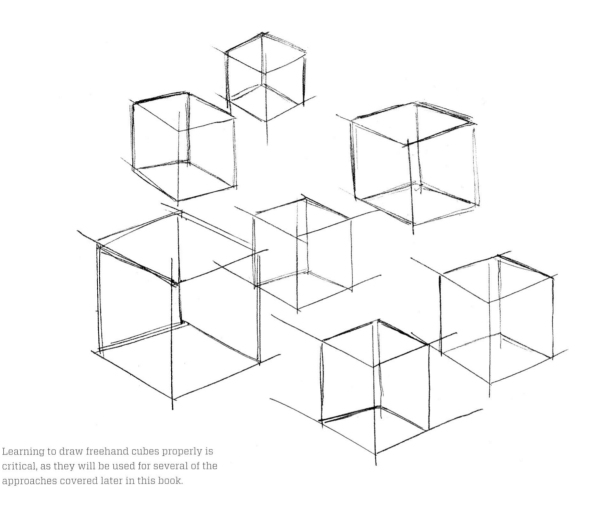

Learning to draw freehand cubes properly is critical, as they will be used for several of the approaches covered later in this book.

MAKE YOUR OWN CUBE

Why is drawing a cube so important? Every inorganic object you observe or want to invent can be constructed with cubes: buildings, cars, chairs, city blocks, and so on. This may sound like an overstatement. It is not.

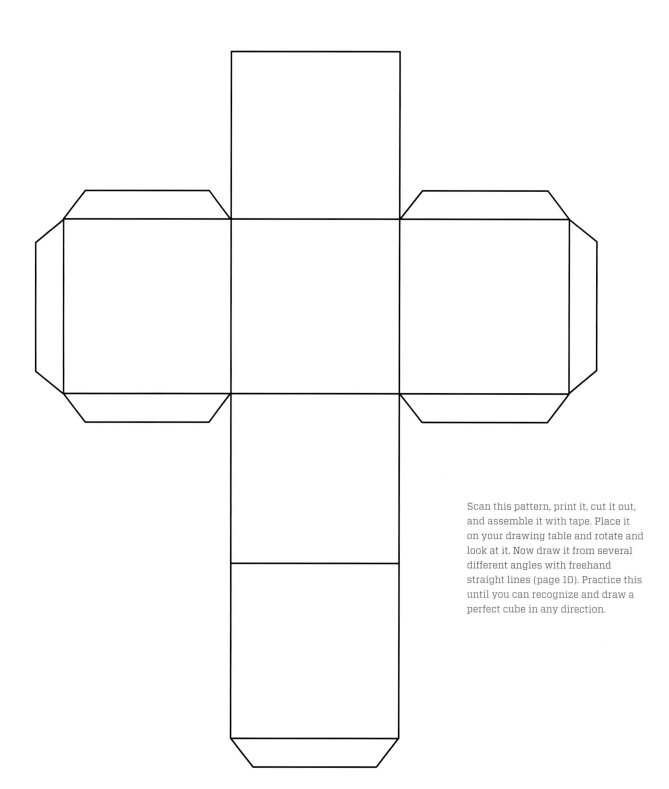

Scan this pattern, print it, cut it out, and assemble it with tape. Place it on your drawing table and rotate and look at it. Now draw it from several different angles with freehand straight lines (page 10). Practice this until you can recognize and draw a perfect cube in any direction.

DRAWING THE PLANES OF THE CUBE

The best way to demonstrate drawing a cube is through a few step-by-step lessons. The cubes I have used to illustrate these principles were designed in Adobe Illustrator for clarity, but I don't use computer programs to make any of my initial drawings.

As you work through these lessons, draw the cubes with a pencil, or a series of colored pencils (varying line color can help prevent confusion), and freehand straight lines. Here you will use a principle called *orthographic projection* to create these cubes; this sounds much more complicated and technical than it really is. Orthographic drawings use a series of parallel lines to give the illusion of depth.

Read and draw along with each of the following examples. Make several of these drawings until they become second nature.

1. Draw a freehand cube.

2. Extend lines from the inside corners so that you can "see" the back of the cube. Imagine that you are drawing a cube made of clear plastic.

3. Draw an X on the front plane of the cube. This will determine the vertical and horizontal midpoints of the cube.

4. Draw a vertical line through the X. When it touches the top line, change directions and draw it across the top. Now draw a line down the back and connect the two bottom lines with a line running across the bottom of the cube. I call this running around the cube.

5. Repeat step 4 with the horizontal midpoint. You have now divided the cube into four sections.

6. This is the horizontal section.

7. This is the vertical section.

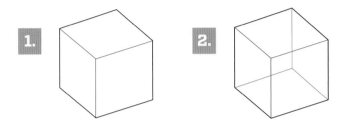

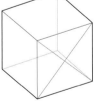

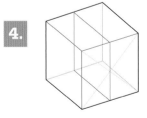

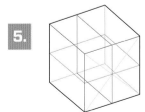

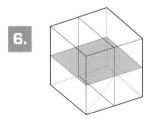

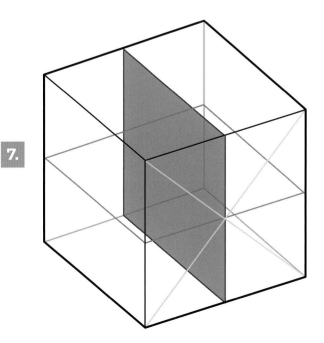

LOCATING SYMMETRICAL POINTS
ON A CUBE

If you have to draw a plane, how do you locate where to place the wing on the far side of the aircraft, the one that's partially obscured by the fuselage? If you need to draw a car in perspective, how do you locate the correct placement of the headlights?

The following lesson will help you understand how to create symmetrical forms accurately.

1. Draw a freehand cube, so all sides are visible, and place a dot on its front plane.

2. Now extend a line parallel to the top left edge, past the cube.

3. Run around the cube until your line intersects the line you drew through the cube.

4. The dot on the other side should be placed, where the two lines intersect.

5. Make another dot on the front plane, in the lower-right section of the cube.

6. Run around the cube along the bottom this time, until your line intersects the line you drew through the cube. Extend a parallel line from the first dot through the vertical line, opposite.

7. You've now located another dot in precisely the same location as the first dot on the other side of the cube.

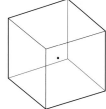
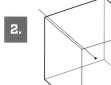

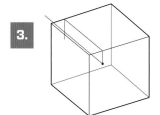
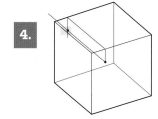

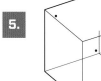
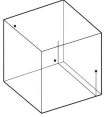
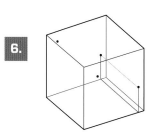

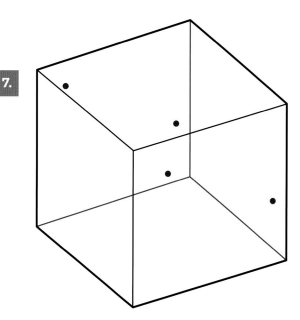

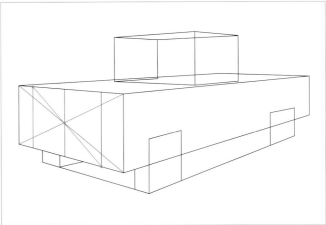

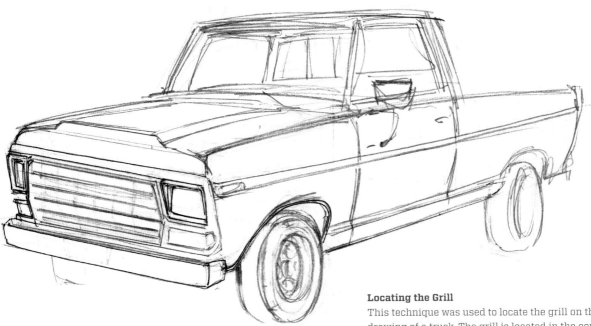

Locating the Grill

This technique was used to locate the grill on this freehand
drawing of a truck. The grill is located in the center of the
front panel of the truck. After drawing a rectangle with the
approximate dimensions of the truck's body, the artist drew an
X in the front section to locate the midpoint. Then, she created
a new section on the left-hand side and used the mirroring
technique to find the other section. This approach also helped
her place the truck's lights.

CREATING OBJECTS BY PLACING SHAPES WITHIN THREE SECTIONS

Finding symmetrical dots and locating and bisecting sections can seem a little abstract initially. This method is easy to understand and will help you begin to visualize objects in a new way.

Create three or more shapes and place them within squares. Draw an isometric shape and place the shapes within their squares and then connect the dots. What did you create?

Isometric shapes are constructed using only parallel lines. So when constructing a cube or a section within a cube, you really only draw lines that go in one of three directions. Look at the lines used to construct the shape here for confirmation.

1. Draw these three simple geometric shapes within three squares.

2. Draw a metric cube and then draw a vertical section in the middle of it. Since the middle square contains a slightly smaller square, draw an X in the middle section of the cube, place a dot on the X. Create a smaller square, using the X as a guide.

3. Draw the other shapes on the front and back of the cube.

4. Connect the corners of all three shapes.

5. Trace the new lines you made with pen. Erase the cube construction drawing. You've just drawn your first object!

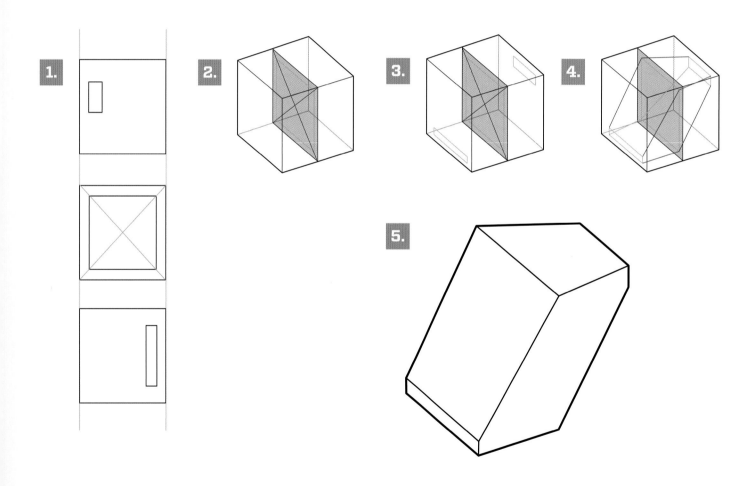

CREATING CYLINDRICAL FORMS WITHIN A CUBE

Your art would look stiff and blocky if all your drawings consisted of straight lines. Cylinders and curved lines add variety to the surface of the objects you draw. Fortunately, you can use squares to help you locate and draw ellipses and cylinders accurately and easily.

1. Draw an isometric cube and place an ellipse on the bottom plane. Remember, an ellipse touches all four sides of a square in perspective.

2. Draw an X on the top plane.

3. Create a smaller square on the top plane, using the X as your guide.

4. Draw an ellipse within this square.

5. Draw lines connecting the two ellipses.

6. You've just drawn a cone.

7. If you turn it upside down, you've just drawn a glass.

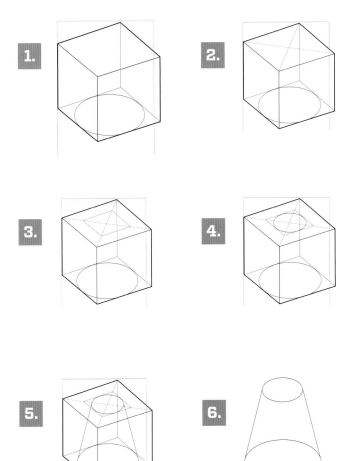

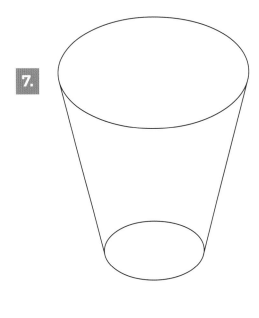

CREATING COMPLEX SHAPES WITHIN A CUBE

Everything can fit within a cube or can be created by using cubes as building blocks. Make that a mantra.

1. Draw a cube and add planes at its horizontal and vertical midpoint. Place X's on the front and one side of the cube.

2. Draw a vertical line through the X on the left-hand side and run it across the top.

3. Draw a vertical line from the point where the top line intersects the vertical section to where it meets the horizontal section.

4. This line creates two new sections on the upper part of the vertical plane.

5. Place a dot on the closest new section.

6. Draw a vertical line through this dot to the point where the horizontal and vertical planes intersect.

7. Locate the midpoint of the line you created in step 3.

8. Draw a line from the top corner through this horizontal midpoint. Stop when you touch the vertical midpoint.

9. Extend the line up to the top.

10. Draw a parallel line from the point you added in Step 5 to the new vertical line.

11. You have now placed two new points within the cube.

12. Make a new point along the bottom plane of the original cube and repeat this process to find its mirrored point.

13. Connect the corners, leaving the back section open.

14. You've just created a complex figure within a cube.

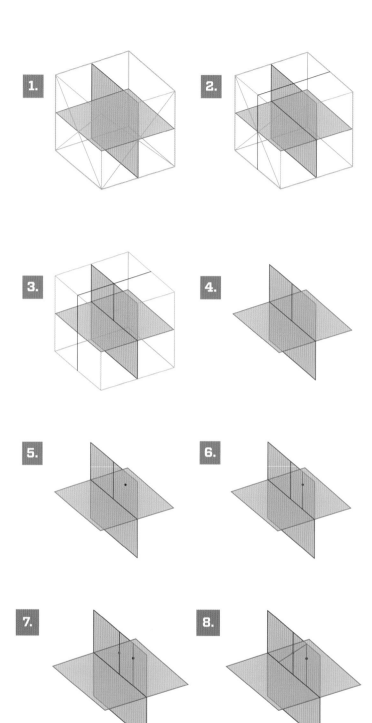

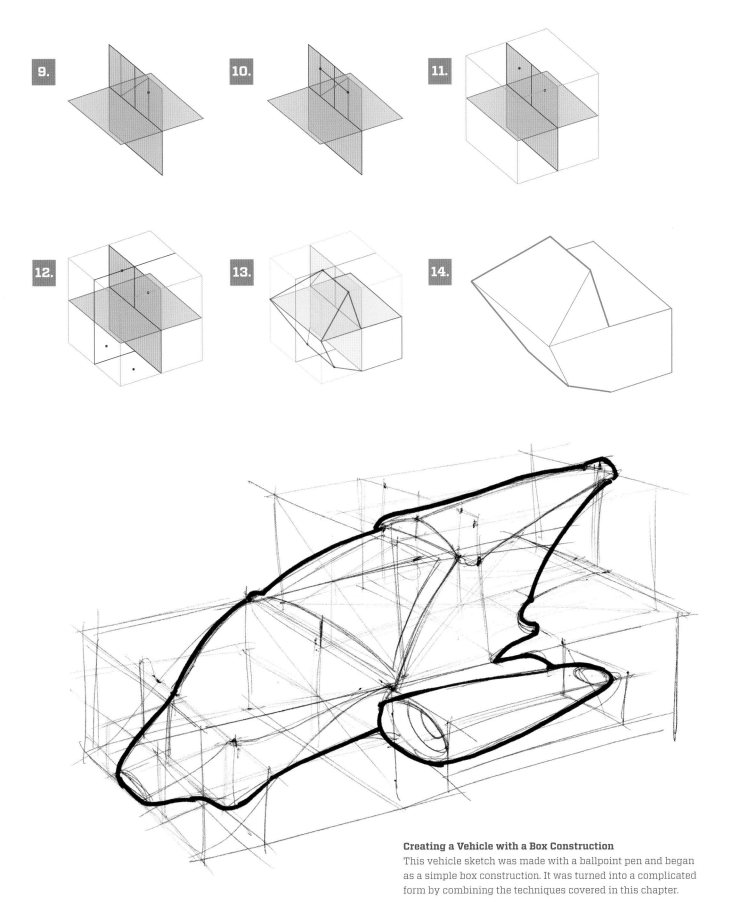

9. **10.** **11.** **12.** **13.** **14.**

Creating a Vehicle with a Box Construction
This vehicle sketch was made with a ballpoint pen and began
as a simple box construction. It was turned into a complicated
form by combining the techniques covered in this chapter.

CREATING COMPLEX CYLINDRICAL FORMS WITHIN A CUBE

When you understand how to locate and draw cylinders within cubes, it's time to up the ante and create more complex drawings by combining cylinders of varying sizes.

1. Draw a cube with a horizontal section at its midpoint. Draw X's on the top and middle planes and place smaller squares within them, followed by ellipses. Draw a large ellipse on the bottom.

2. Draw lines connecting the ellipses.

3. Erase the construction drawing. You now have a curved cylindrical container.

1.

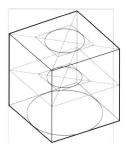

TIP

Train yourself to see past the complicated surfaces of objects to find their underlying forms. This jet engine is really just a set of ellipses of varying sizes.

2.

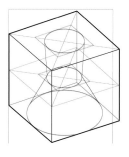

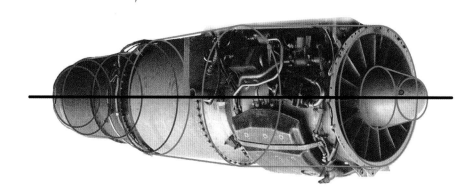

3.

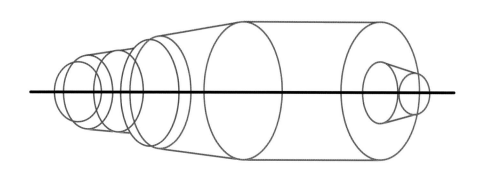

Perspective Drawing

Almost all drawings use perspective. The only ones that don't are easily recognizable—they're flat illustrations, such as logos or hieroglyphs. Perspective gives drawings an element of depth. A comic artist must have the ability to draw people and environments from any vantage point quickly and accurately. Therefore, proficiency in perspective drawing is a required skill.

When it is taught properly, perspective drawing isn't very hard. The key is to take your time and fully master each technique before moving on to the next. At times you will probably become confused. When that happens, read the lesson again and keep making drawings until you understand the principle fully.

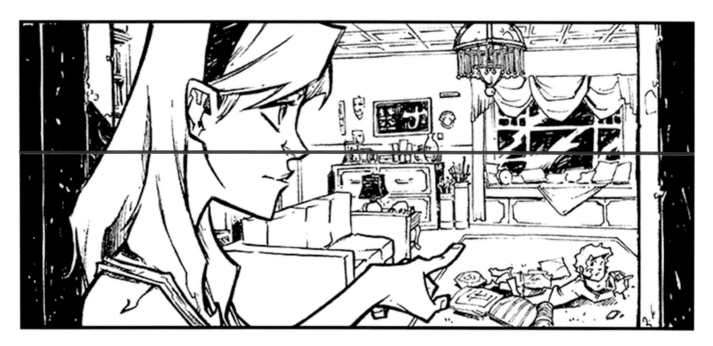

The red line indicates this drawing's horizon line. Think of the horizon line as a camera's lens; you also may want to think of it as eye level. In this drawing, the lens's eye level is just below the woman's ear.

COMMON ELEMENTS IN PERSPECTIVE DRAWINGS

- *Horizon Line*: The horizon line in a drawing represents the viewer's eye level. The easiest way to understand this concept is to think about using a camera. You look through a viewfinder or at a screen display to frame a picture. Although you can move the camera up and down, your eye level—the distance between your eyes and the ground—remains the same.

- *The Standard Horizon Line*: Most family photographs are taken by someone standing directly in front of his or her subjects. This means the horizon line (eye level) of those photographs falls somewhere between 5 feet 6 inches and 6 feet.

- *The High Horizon Line*: If you take a picture from the balcony of a very tall building, your eye level is hundreds of feet in the air. In comics, this eye level is referred to as a *down shot* or a *bird's-eye view*. These angles often are used in comics to establish a scene's setting.

- *The Low Horizon Line*: If you lie on your stomach and take a picture of a toddler, he or she will appear huge because your eye level is just a few inches from the ground. In comics, this eye level is referred to as an *up shot* or a *worm's-eye view*. In storytelling, a low horizon line is usually used when you want to make a person or object look imposing and powerful.

When you're drawing, *every panel* on *every page* should have a horizon line, even if there aren't any backgrounds in the panel.

When any object begins to turn away from you, its sides begin to recede, diminish, and converge toward vanishing points.

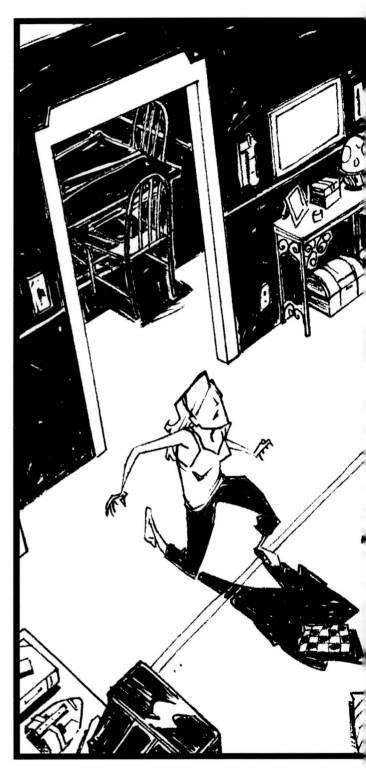

In a drawing like this one, where the eye level is very high (picture yourself on the third floor of this house looking down), the horizon line lies outside the panel.

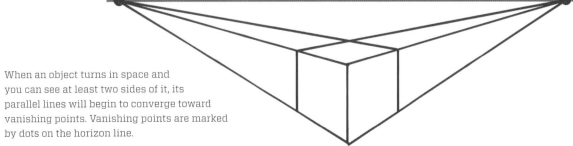

When an object turns in space and you can see at least two sides of it, its parallel lines will begin to converge toward vanishing points. Vanishing points are marked by dots on the horizon line.

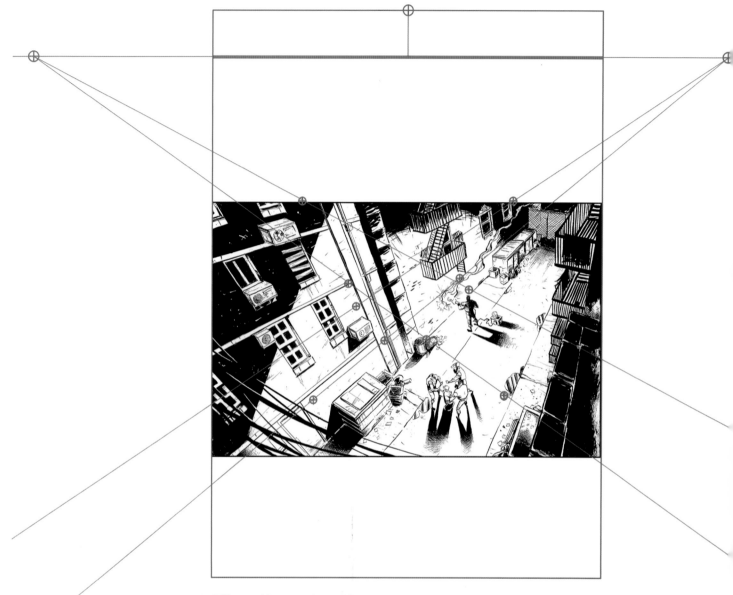

Different objects can have different vanishing points, but with a few exceptions
I'll cover later, those vanishing points must be located on the same horizon
line. Think of the horizon line as representing your eye level. The easiest way to
understand that is to think about taking a picture. The horizon line is your eye
level as you look through your viewfinder. In most snapshots, the eye level is
somewhere between five to six feet—the height of the person taking the picture.
However, if the same person took a picture from the balcony of a fifth-floor
apartment, the eye level, or horizon lines, would also be located five floors above.

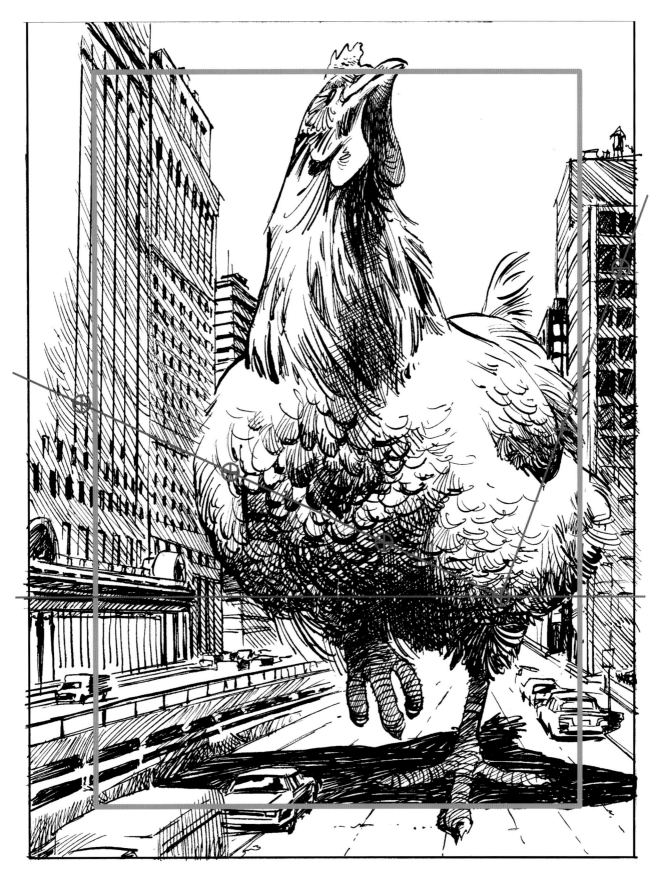

The horizon line in this drawing is very low in the composition. A
low horizon line makes this subject look imposing and powerful.

ONE-POINT PERSPECTIVE

A one-point perspective drawing is made up of vertical, horizontal, and perspective lines. All the vertical lines in the drawing are parallel to one another, all the horizontal lines are parallel to one another, and all the lines that recede converge toward a single vanishing point.

One-point perspective drawings are a useful learning tool (the single vanishing point prevents confusion), but they aren't very practical unless you are drawing a single item from one side. As soon as an object turns, you see two sides of it, and when that happens, you need two vanishing points.

One-point perspective drawing often is used in comics to direct the viewer's attention.

TWO-POINT PERSPECTIVE

A two-point perspective drawing is made up of perspective lines that recede to one of two vanishing points and vertical lines that are parallel to one another. However, although any given object uses two established vanishing points, remember that other objects in the drawing, when moved, may need new vanishing points. Any time you see two sides of an object, perspective drawing is required. The nearer part of the object is closer to you, and therefore bigger. Lines begin to converge as the object recedes into space. Look at the illustration below.

Almost every object you draw in two-point perspective has vanishing points on one horizon line. The only exception to this is an object that is tilted up or down. For example, if you are drawing a table covered in books and one of the books is resting on another book, its lines will converge and recede toward a new horizon line.

Two-point perspective is the most commonly used drawing technique in comics, and once you understand it, three-point perspective is a snap.

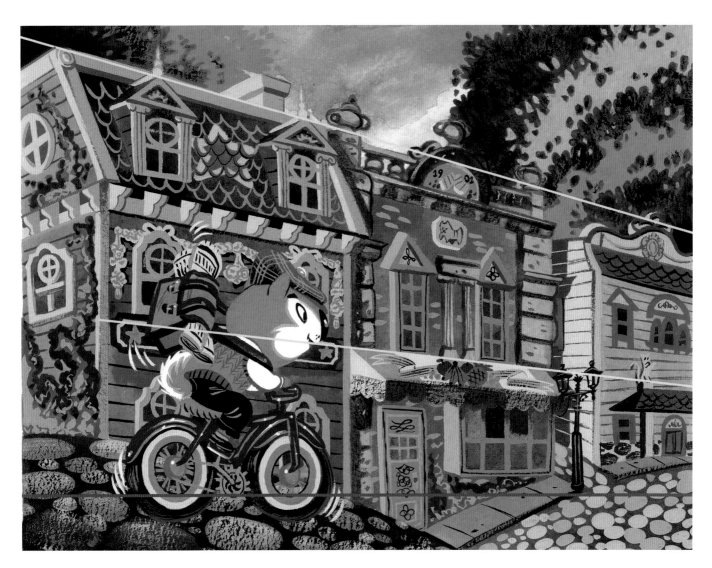

All the lines within any single object converge to one of two vanishing points located on the horizon line.

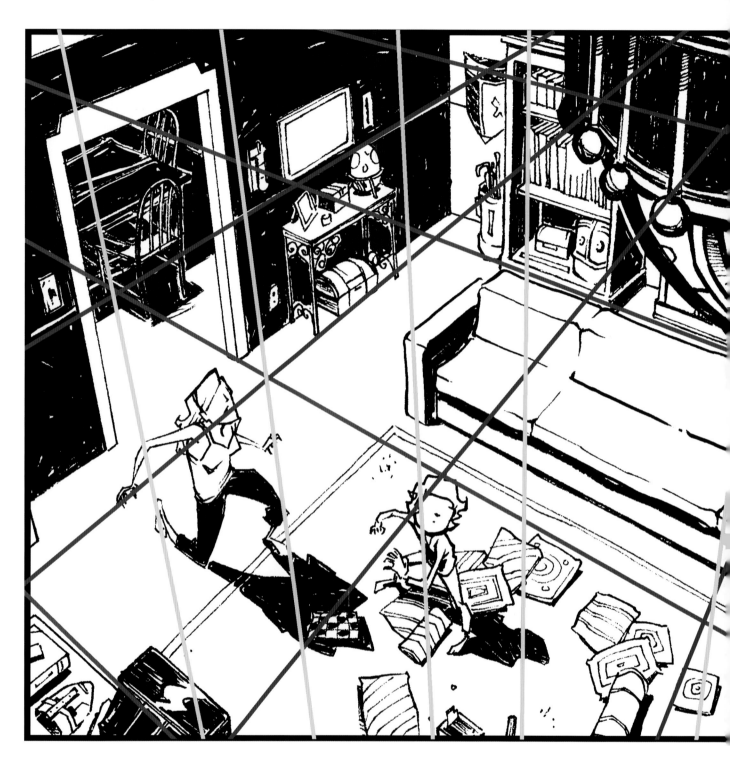

Observe the lines crossing from three vanishing points. Three-
point perspective can provide viewers with the sense that they are
viewing a scene through a wide-angle lens.

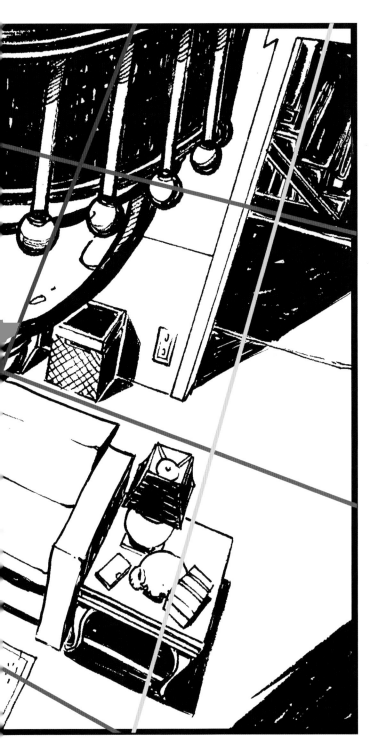

THREE-POINT PERSPECTIVE

In three-point perspective drawings, *all* the lines converge to points. The third point serves as a nexus for all the vertical lines in the panel, and it can be placed above or below the horizon line. The third point needs to be placed far from the horizon line. If it isn't, the converging lines will make the drawing look distorted.

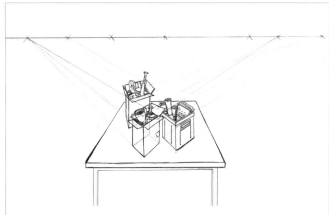

The tabletop is drawn in one-point perspective in this drawing, but the cubes sitting on its surface are drawn in two-point perspective. Because the cubes are turned in different directions, each of them has a different set of vanishing points.

Placing Objects

Have you ever drawn several people in a room, only to realize they don't look like they're all standing on the same floor? Have you ever been confused when you try to place objects in an interior space? How do you know that the objects you've placed in your drawing are spaced correctly on the ground and are in perspective?

HOW TO REMEMBER ESSENTIAL INFORMATION ABOUT OBJECTS

The questions above should sound familiar. Every artist I know has dealt with them at one time or another. The inability to create believable environments is frustrating, and can limit, if not prevent, a career in comics.

Fortunately, they don't have to be so daunting. You just have to simplify how you see things. The only information you need to draw inanimate objects in perspective, and place them correctly, is the object's height, width, and depth.

The easiest way to visualize this concept is to imagine a box fitting around whatever you are drawing. If you needed to build a wood-paneled box for your refrigerator, how tall would the wood need to be? How wide would the panel need to be to cover the front and back? How long would the sides be?

Next, look for significant details. My refrigerator has a top and bottom door. The bottom door takes up approximately two-thirds of the refrigerator's height. The freezer door takes up the top one-third of the overall space, and there is a small vent under the bottom door. The door handles are on the left-hand side, and they are set in from the edge slightly.

1. This is the front and side view of a simplified refrigerator. Since a refrigerator's exterior isn't complicated, you only need a front and side view to construct it, from any angle.

2. Start by drawing a rectangular box, with the approximate dimensions of your refrigerator.

3. Locate a point on the box's NEAR corner that corresponds with the division between the refrigerator's bottom and top doors. Mark it with a dot.

4. Using the dot as a starting point, draw a contour line across the front of the box. Extend the line along the box's left side slightly to indicate the refrigerator's doors, which are relatively narrow. Draw a vertical line up the side of the box, from the end of this line.

5. Place dots on the NEAR corner to indicate the placement of the door handles.

6. Draw horizontal lines from these dots across the front of the door.

7. Draw two dots at the top, front edge of the box, corresponding with the handles' width and placement.

8. Draw vertical lines down from these dots.

9. The intersecting lines create two rectangles. You will place your handles here.

10. Extend horizontal lines out from EACH corner of both rectangles.

11. Decide how far out you want to extend your handles, and draw a horizontal line across the two bottom lines. Extend a vertical line up from the near corner.

12. When your line reaches the top near corner, change direction, and draw another horizontal line until it reaches the other line. Then draw a vertical line down to the point where you began. You now have a construction drawing of a refrigerator in perspective. Now fill in some details!

1.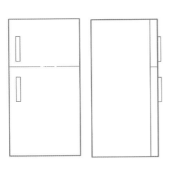

2.

3.

4.

5.

6.

7.

8.

9.

10.

11.

12.

GRAPH PAPER

You can, and should, use graph paper to draw a floor plan when need to draw complicated interior and exterior environments. This plan allows you to visualize how the room, or scene, will look from different angles, and prevents you from making mistakes concerning the arrangement of objects.

Graph paper helps you to reduce the objects you intend to draw to basic geometric shapes. Because the paper uses a grid comprised of perfect squares, you can use them as units of measure. The area that a square represents is up to you. Each square could represent a foot, ten feet, or a hundred feet.

For this example, I've decided each square will represent one square foot. I've plotted out a simple bedroom, and used squares and rectangles to note the lengths and widths of every object within it.

THE PERSPECTIVE GRID

Now it's time to place these in a perspective grid! (For more on using Photoshop to create grids, see "Creating a Grid in Photoshop" on page 124.)

You can find several perspective grids with a quick Internet search. The most important factor when working with a pre-drawn grid is to make sure that the grid lines create *perfect squares* in perspective.

Since your graph paper is comprised of squares, all you have to do, initially, is transfer your simple geometric shapes onto your perspective grid. Transferring shapes from graph paper to the grid is as easy as counting squares.

The best part about this method is that there is no guesswork as to where things overlap, and you know that all the objects you draw lie on the same ground plane.

As your skills develop, you may notice that using a pre-drawn grid isn't necessary; you can construct your own freehand grids and develop your drawings within those. However, it's best to use pre-drawn grids, with *perfect squares*, until you have mastered perspective drawing.

1. This is a two-point perspective grid comprised of perfect squares. You can use each square as a unit of measurement. If you've created a floor plan with graph paper, you can easily transfer it onto a perspective grid.

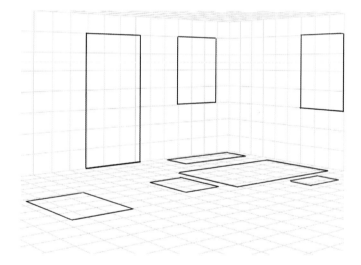

2. Each square, on both the floor plan and perspective grid, represents a square foot. Transfer the floor plan pattern onto the grid. Add a doorway and some rectangles onto the walls.

3. The bed in this room is
 approximately two and
 a half feet off the ground.
 Extend lines from the
 rectangle that represents
 the bed to the line that
 represents where the
 floor and wall meet. Draw
 vertical lines two and a half
 feet high. Connect with a
 horizontal line.

4. Draw vertical lines from
 EVERY corner of every
 rectangle on the floor. You
 will use these for each
 object in the room.

5. Using the grid's horizontal lines as a guide, extend lines from the corners of the wall pattern until they touch the vertical lines extending from the opposite corners of the rectangle that represents the bed. Note: I removed the other vertical lines for clarity's sake.

6. You've just created a box that is two and a half feet high, six and a half feet long, and four and a half feet wide.

7. Use this same procedure for every other object in the room. The wall grid allows you to determine the varying heights of the objects.

This technique removes any guesswork—you know where objects overlap, and that each object is placed correctly on the wall or ground-plane. Adding additional visual information gives the room character and suggests the type of person who lives there.

4
THE FIGURE

Gesture Drawing

Creating dynamic figures quickly is fundamental for a comic book artist.

Gesture drawing is quick, easy, and fun. You should never spend more than two or three minutes on a gesture drawing, and it can be done in as little as five seconds.

When making a gesture drawing, you should try to feel the pose and convey that feeling on the page. One of the best ways to do this is to actually take the pose, noting the various twists and turns that occur in your body and the way those positions affect your muscles.

Try this: Bring one leg forward and lean your torso over it. Can you feel the muscles in your thigh contract as the weight of your body shifts to that leg? Or try this one: Clasp your hands together and raise them high over your head in an exaggerated stretch and then lean back. Do you feel your lower back contracting as your abdomen stretches out?

Translate those feelings to lines on the page. Don't be afraid to exaggerate in your drawings. Gesture drawing is about communicating an idea, not making a beautiful work of art. Have fun with it. Use any drawing tool you have handy: a pencil, a ballpoint pen, a crayon, a broad piece of charcoal, or a fountain pen.

Try different approaches. Pick up a ballpoint pen and make a drawing without lifting the pen from the paper. Allow it to flow around and through the drawing as you observe your model. Try holding the pencil so that you learn to draw with your entire arm, not just your wrist and fingers.

Gesture drawing is a great way to warm up when you get to the drawing board.

Make it a daily practice. From there, you can then move to more complex figure studies.

If there is a college or art center in your city, check to see if it offers figure drawing sessions you can attend. If it doesn't, look for websites that have interesting photos to reference. These two websites were set up for artists looking for figures to draw:

- www.posemaniacs.com. This website has thousands of poses, and you can rotate each pose 360 degrees. The male and female models are skinless computer renderings (so that you can study the underlying musculature of the bodies). This will improve your drawing and help you better understand anatomy visually.

- www.artists.pixelovely.com. This website is full of photographs of both clothed and nude models. The home page allows you to choose whether you want to draw clothed, nude, or both and allows you to select the subject's gender (or draw both sexes). You also select the amount of time you want each pose to be displayed.

This is a sketchbook page of one-minute gesture drawings.

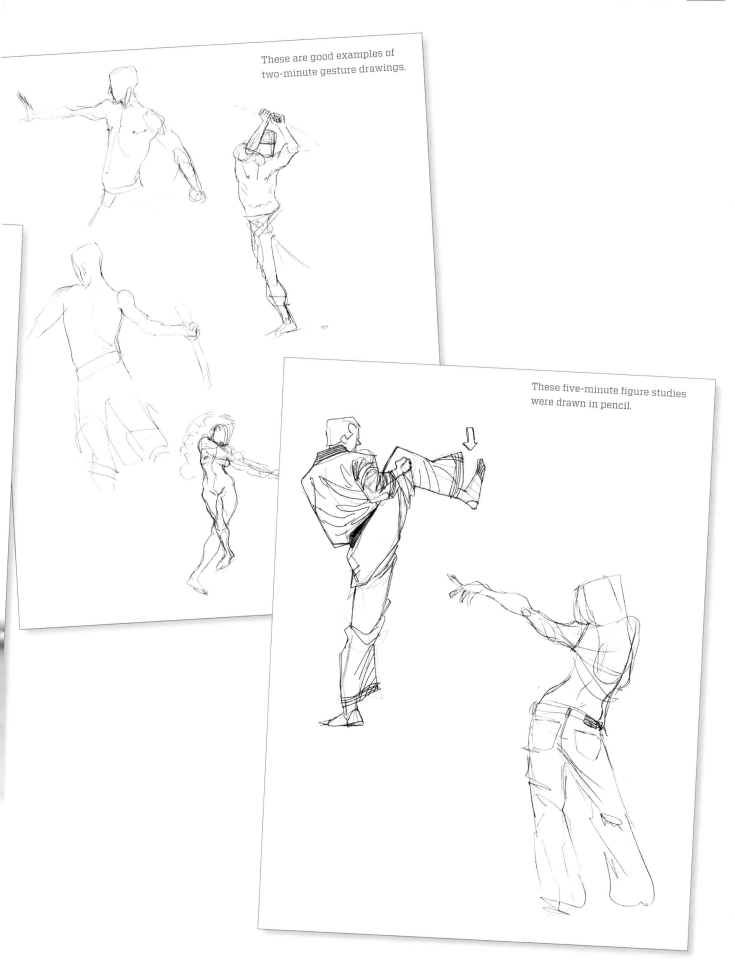

These are good examples of two-minute gesture drawings.

These five-minute figure studies were drawn in pencil.

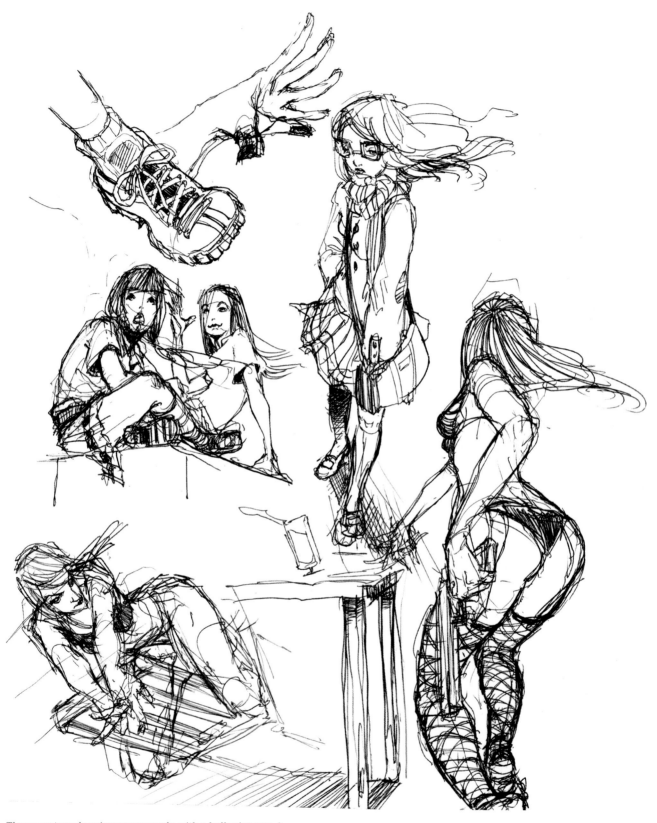

These gesture drawings were made with a ballpoint pen. A
ballpoint pen is a good tool for this exercise because it forces
you commit to the marks you make.

Foreshortening

Foreshortening occurs when a figure or object is viewed at an unusual angle.

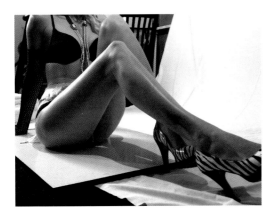

In this photograph, the model's leg is very close to the lens, causing it to seem unnaturally large in relation to the rest of her body. You can use this effect to create dramatic drawings in your comics.

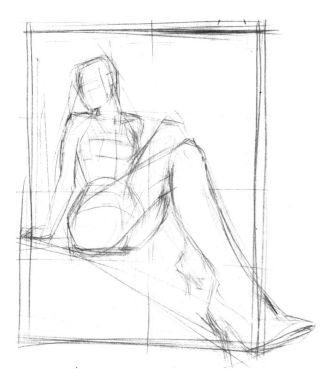

Start with the body part nearest you when you draw a foreshortened figure. It will serve as a reference point and help you determine the size and placement of the model's other features.

Now draw your own foreshortened figure, using your construction drawing as a reference.

DRAWING FIGURES FROM MEMORY

Memory drawings help you improve your visual memory and vocabulary. When you have a limited amount of time to take in as much information as possible, you train yourself to process the salient information without delay. You learn to identify plumb lines, angles and relationships between the pelvis and the shoulders, and directional angles of limbs, and to locate horizontal and vertical midpoints quickly.

It's best to start this practice by using photographs. With a quick Internet image search, it's easy to locate very interesting poses that couldn't be held by live models. Cameras can capture gymnasts, martial artists, and other athletes in motion.

The process for this exercise is identical to the techniques you used for drawing objects (see page 3).

If you perform this exercise often, you'll improve your retention of visual information in a short time. It will train you to separate significant details from the superfluous, and you'll soon be ready to draw moving figures from life.

Look at a picture of a figure for *one minute*, taking mental notes and committing as much information to memory as possible. Note any visual information that will help you draw the image when the picture's no longer in front of you. Is one shoulder higher than the other? How are the elbows, knees, and feet placed? What is the figure's vertical midpoint? Its horizontal midpoint?

Minimize your window or turn away from your monitor or photograph and complete a figure drawing of the subject in *two minutes*, using a blue pencil.

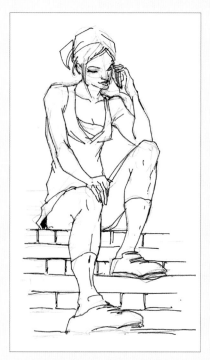

Pick up a ballpoint pen, look at the photograph, and make a *two-minute* observational drawing on top of the pencil drawing. Note what you got right and wrong.

Drawing Multiple Figures

Drawing several figures within the same panel is one of the first major challenges a budding comic artist faces. I'll show you a couple approaches that you can take, but one of the best ways to overcome this hurdle is to make a habit of making multiple-figure compositions in your sketchbook. A quick Internet search will provide you with interesting photos taken from a variety of vantage points.

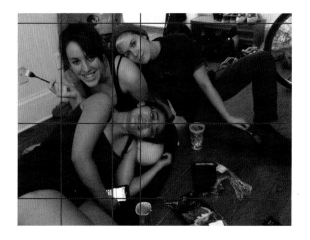

Observational drawing requires you to make a visual analysis of whatever you intend to draw. The subject really doesn't matter; it could be a still life, a car, a feral cat, or a group of people. I begin by looking—really looking—at my subject. I note plumb lines, angles, quadrants, and midpoints.

My approach to drawing a group of people is very similar to my approach to drawing a foreshortened figure: I begin with the person in the foreground; it's the shape that takes up the most space. When I have established that figure, I use it as a reference point to help me place all the other figures in the composition.

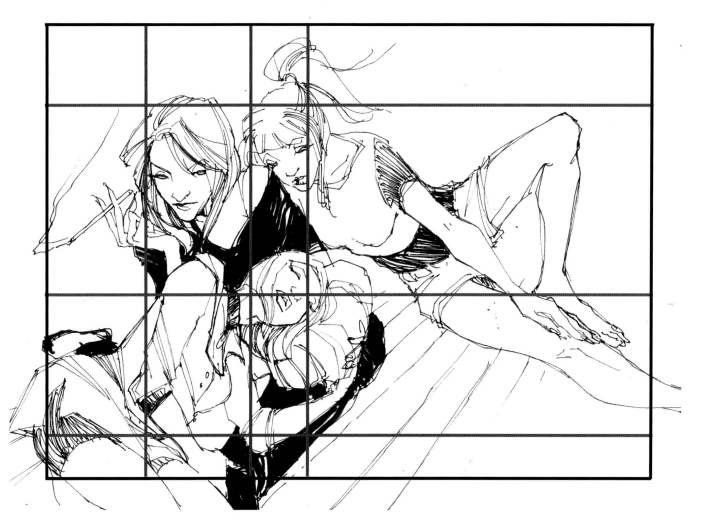

It's best to draw the closest figure first when you're drawing a group of people. Then use plumb lines and quadrants to help you place the other figures.

You can transform an ordinary photograph into a dynamic drawing. The photograph serves as a springboard for the drawing and can help you visualize a difficult pose or composition. Once you have blocked in the basic shapes and gestures, you can take as many liberties as you want.

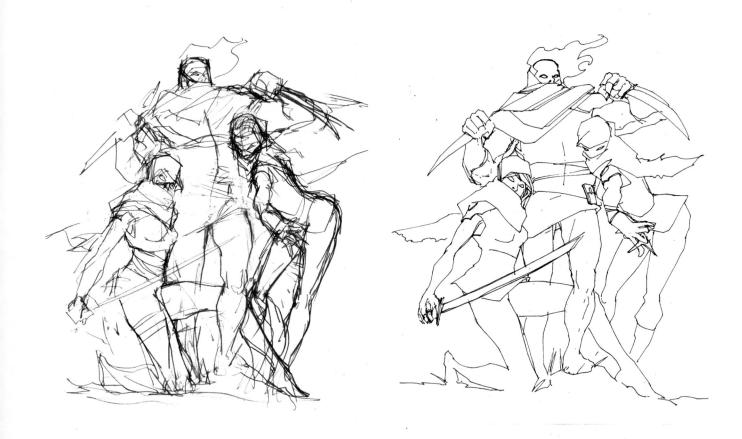

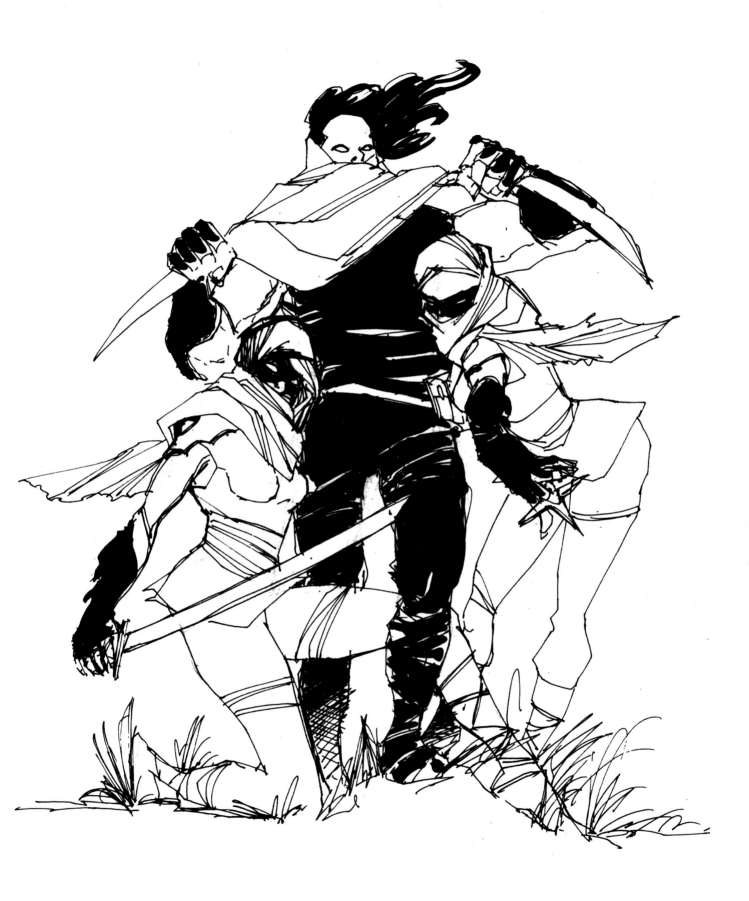

5

VISUAL PROBLEM SOLVING

Thumbnail Drawings

Thumbnails are small sketches used to generate visual ideas quickly. They allow you to create multiple versions of specific panels or entire comics pages in a short time.

Generally, comic artists draw two types of thumbnails: rough and tight. Rough thumbnails can be as small as an inch or two in height. This prevents you from overrendering a drawing and also forces you to concentrate on the arrangement of shapes within a panel and the way the shapes within individual panels "read" when placed side by side on a page.

You can even use an iPad or any other pressure-sensitive digital tablet to create rough thumbnails.

Most comic pages are drawn on Bristol board, which has blue lines and guides printed on it to help ensure that the panel borders have a consistent width and that the ratio of height to width is correct.

You can also use templates for creating your thumbnails. Templates are just smaller versions of comic pages, and they are easy to make. Simply scan a page that has these guides and reduce its size in Photoshop. Two-, four-, and eight-page templates printed on 8.5-inch by 11-inch printer paper are used the most frequently by comic artists.

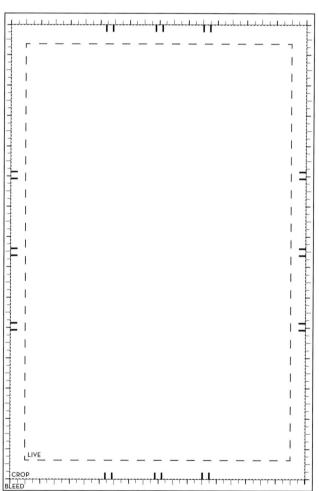

If you scan this example into Photoshop, you can create your own templates, fitting two, four, or eight pages on a single sheet of 8.5-inch by 11-inch printer paper.

This artist used a template to create thumbnail layouts for his story. Each page is approximately 2 inches by 4 inches. The small size makes you consider composition and the use of small shapes. At this stage, details are unnecessary.

When you have determined the final compositional layout of a page using rough thumbnails, you may find it helpful to create tight thumbnails. Tight thumbnails are drawn on a larger sheet of paper. Most artists use an 8.5-inch by 11-inch sheet of printer paper with printed guidelines that correspond to an 11-inch by 17-inch Bristol board page. The larger drawing area allows more details to be added and makes drawing horizon lines and vanishing points

manageable. These templates also create consistently spaced panel borders, and you can enlarge them in Photoshop to a standard-size art board.

Some artists prefer to draw individual panels on separate pieces of paper. When they have finished all the drawings for a page, they scan them and organize them with a computer program.

This artist created her tight thumbnails with a computer. With tight thumbnails, you can include more details, like indications of shadows and text box placements.

COMPOSING THUMBNAILS

Create three to five rough thumbnail compositions for the following scene. Make very small panels, no larger than 1 inch by 2 inches, for each of your drawings.

INTERIOR, PRIVATE DETECTIVE'S
OFFICE — DUSK
A man wielding a gun enters the PI's office, threatening to shoot him. The detective is behind his desk, bottle in hand, cigarette in mouth. An older woman holding a small dog is seated across from him. She's laughing at the man with the gun.

Ask yourself a few questions before you begin drawing: What does the detective's office look like? Is it clean or filled with clutter? If the latter, what kind of clutter? How would you draw this scene if you wanted to make it dramatic and place the emphasis on the man with the gun? What if you wanted to make it comedic? How many ways can you arrange these three people and a small dog in this environment?

Have fun!

Research and superb drawing and compositional skills were necessary to create this interesting and specific interior space. Try recreating the thumbnail that the artist may have used to compose this image.

Using Photo Reference

If I were given a dollar every time I heard someone say, "Using photographs for reference is cheating," I'd be a rich man. It's a common misconception and one that I shared when I was younger. I thought that a real comic artist could draw anything from his or her imagination. However, although some artists don't rely heavily on photographic reference, almost all of them have to use it at some point.

A photograph can help you capture any number of poses. Several artists I know who have to draw a page a day use themselves exclusively as their models; they're both artist and muse. Photo reference for objects and environments also allows you to add specific details, which prevents your images from being too generic.

The only thing you want to avoid is being a slave to photographs, simply tracing a picture to create a drawing. Unless you're a skilled photographer and know how to avoid the visual distortions created by different focal lengths, most of your photographs will be distorted to some extent, and if you simply draw on top of them, your drawings will look awkward and stiff.

However, if you use a photograph as a point of reference to help you visualize a difficult pose, it can be an extremely useful aid. Taking photographs today is easier than ever. Digital cameras can be purchased for under $20, and almost every smartphone has a camera built into it.

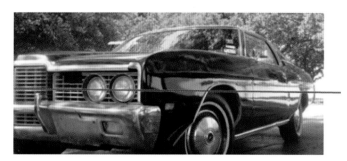

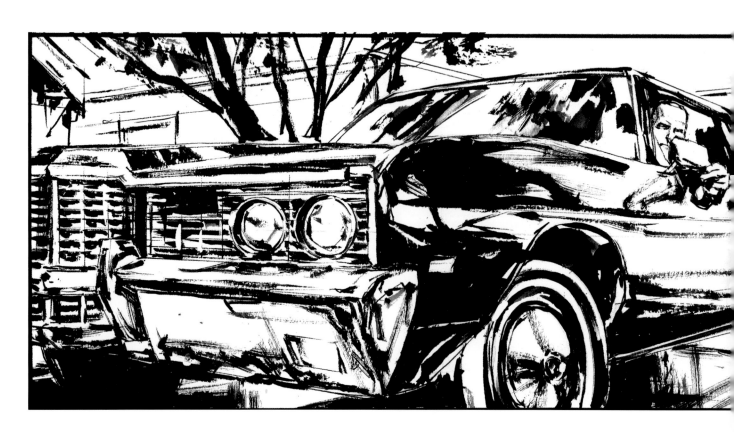

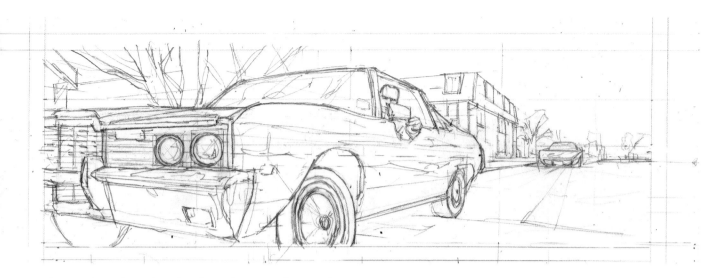

This panel was drawn by using those pictures on the opposite page for reference. You can use a projector, light box, or software program to create a composition that incorporates your photo reference. However, remember that your photos are *reference*, and you can't simply trace over them.

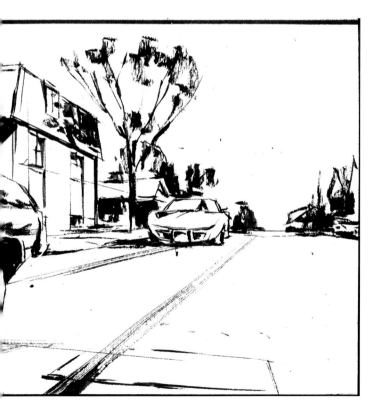

The final inked image is impressive. It is well composed, the car and buildings have specific details, and the black placement and inking make it very energetic. The photographs of the car and building allowed the artist to give the illustration specific, idiosyncratic details.

Visual Research

Consider this scenario: You've just been assigned a story that takes place in New York City in the 1920s. The main character, David Duncan, has an office in the Flatiron Building, but he commutes daily via commuter train from his suburban house in White Plains, New York. Each day, Mr. Duncan stops at a newsstand in Grand Central Station to purchase three newspapers: the *New York Herald Tribune*, the *New York Times*, and the *Evening World*.

These newspapers will become significant later, after Mr. Duncan is framed for the murder of a prestigious stage actress. Each of these papers documents his arrest and the salacious allegations in front-page stories.

Mr. Duncan is incarcerated on Blackwell's Island (the majority of the story will take place here) before being exonerated.

To do this story justice (pun intended), you'll need to do a lot of research. In addition to finding photos of all the buildings involved, you'll need to find references for the various types of clothing worn in the 1920s by these character types: successful businessmen, street vendors, policemen, and so forth.

Since the newspapers play a prominent role in the story, you'll need to find images of them from this era and deconstruct the way they were designed. How did the front page of each newspaper appear? What typeface did each paper use?

Since the majority of the story takes place in a penitentiary, you will have to learn about its history. Who was imprisoned there? What were the living conditions?

You get the idea.

TRY IT

Here is a good and enjoyable way to create unique characters: take photographs of friends and exaggerate their features. Turn them into heroes, villains, monsters, and the like.

IMAGE COLLECTIONS

Before the Internet was ubiquitous, locating reference material could be a tedious and time-consuming process. Illustrators used to collect photographs from magazines, separate them by subject, and house them in drawers and filing cabinets. This type of reference collection had a specific name: *morgue.*

The good news is that researching is easier than ever. It's just a click away. Everyone knows Google and Wikipedia, and generally, these two sites can either provide you with all the references you need, or suggest another specific website that contains the material for which you are looking.

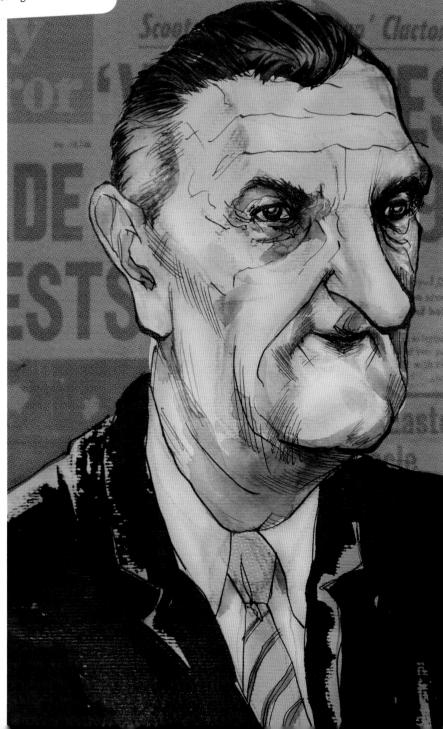

I used Google to find references for the thirty-sixth American president, Lyndon Baines Johnson (LBJ), when I began this illustration. I was able to locate numerous photographs and newspaper headlines in a matter of minutes from my desk at home.

Using Photoshop with Photographic Reference

You can use Photoshop or other software programs to help you incorporate photographic reference into comic drawings.

You can import a photo into Photoshop by using a scanner, or by opening up a photograph you have on your computer. Take a photograph and import it into Photoshop. Most photographs will be imported as RGB (Red-Green-Blue) files (full color). Change the image mode to greyscale (Image > Mode > Greyscale).

This new Photoshop file is assigned to the background layer, and that layer is locked (meaning you can't alter it). Right-click the layer and a new dialogue box will appear. Click "Layer from Background." You can now change the name of the layer (but you don't have to) and click OK. The layer is now unlocked.

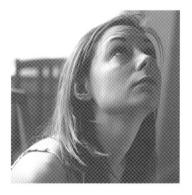

Lower the opacity of the layer to approximately 83 percent and create a new layer (Layer > New Layer). Once the layer is unlocked, you can change the opacity by using the slider bar in the Opacity window.

Change the image mode back to RGB (Image > Mode >RGB) and create a new layer. Select a brush or pen tool and a color and draw on top of the photograph, using it as a point of reference. Block in basic shapes and significant features that will help you create your own drawing.

At this point, you can trash the photograph or click the eye symbol to make it disappear. The eye symbol is located on the left-hand side of every Layer created in Photoshop. Lower the opacity of the drawing you just made to less than 50 percent. Create a new layer and select a new color. Refine your drawing.

If you work digitally, you can create your final drawing on the computer. If you prefer to finish the drawing by using a pencil, as I do, delete all the previous layers, lower the opacity of the final drawing to approximately 20 percent, and print it out. The lowered opacity creates a faint print that you can draw on top of.

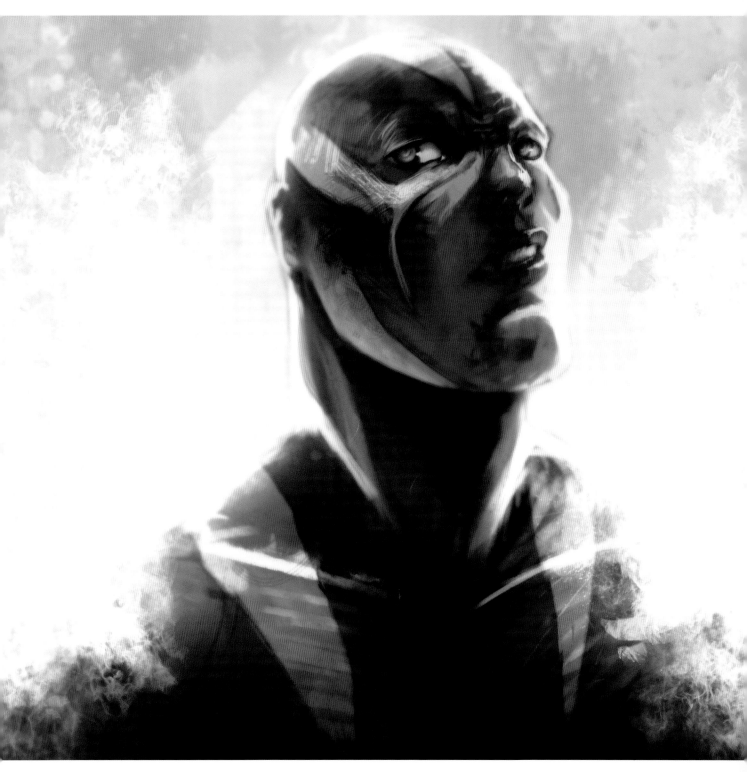

Robert Bouches used Photoshop over my initial pencil drawing
to create this full-color digital painting.

Creating Blue Line Pages to Ink

When you have completed your drawings, scanned them, and designed the final page, use a large-format printer (a printer that can accommodate an 11-inch by 17-inch page of Bristol board) to make a blue-line print.

USING PHOTOSHOP TO CREATE BLUE LINE PRINTS

Pencilers used to send comic art to inkers via FedEx or UPS, but the computer has made that unnecessary. Today a penciler can scan his or her artwork and send it to an inker via email. The inker downloads the image, converts the lines from gray to blue, prints the page out on Bristol board, and inks it. When the inker has finished the page, he or she scans it. With a few quick adjustments, all the blue lines drop out, leaving only the ink lines.

Even if you ink your own pages, you may want to use this method, because you won't need to erase the page when you're finished.

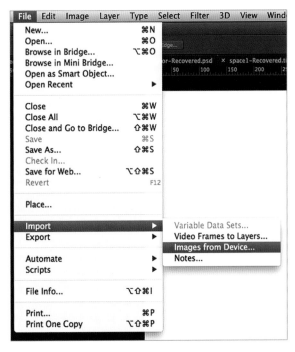

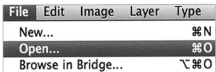

1. Open Photoshop and choose File > Import > Images from Device. If you have already scanned the page, choose File > Open.

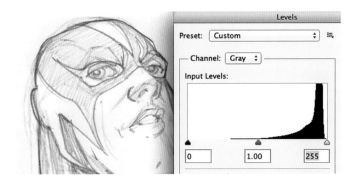

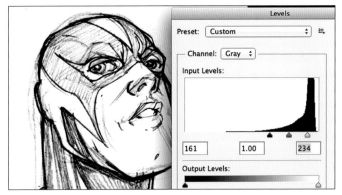

2. Scan the penciled page as a greyscale image at a minimum of 300 dpi (dots per inch) and save it as a JPEG or PNG file. When it opens in Photoshop, you may want to adjust the image by using levels. Choose Image > Adjust > Levels and use the slider bars until you are satisfied with its resolution.

3. Choose Image > Mode > Duotone. A box titled "Duotone Options" will open. Click in the Ink 1 color window and the Color Picker window will appear.

BLUE LINE

The term *blue line*, as it applies to comics, is a carryover from the pre-personal computer age. Artists used light blue pencils and markers to make construction underdrawings of figures and compositions. When the drawings were finalized, the artists would complete their illustrations in pencil or ink on top of the blue structural drawings. The blue lines would disappear as if by magic when they were photocopied. Erasers weren't necessary.

4. The C (cyan), M (magenta), Y (yellow), and K (black) channels are located in the bottom-right section of this window. Change the C channel to 18%, change the M to 7%, and set the other channels to 0%. There is a lot of latitude here; as long as you zero out the K channel, you can ink the page and drop the other colors out later by returning to these settings.

5. When you have made your selection, type "blue line" in the window by the new color you have created. The page has now been converted and is ready for printing and inking.

TIP

If you prefer to draw each panel on an individual piece of paper (I like working on printer paper, which is inexpensive and seems less precious), you can scan them in individually and arrange them with software such as Photoshop or Manga Studio.

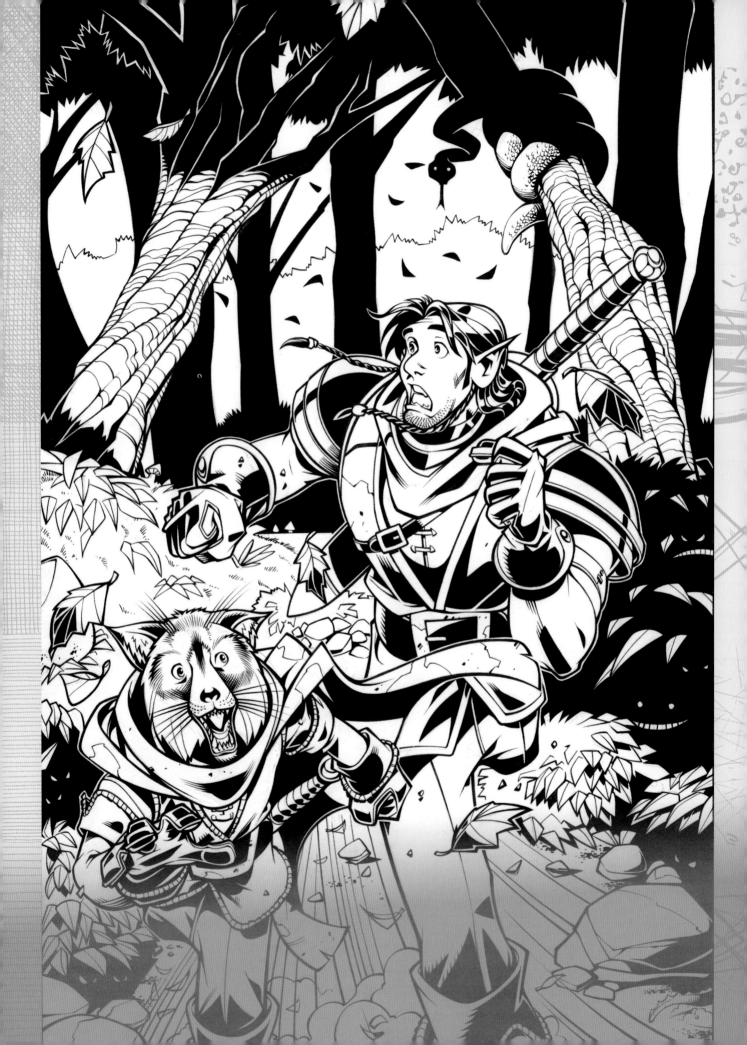

6
INKING

Inking Tools

Although technology has made it possible to ink artwork digitally, the majority of comic book pages still are inked with a pen or a brush. These tools are remarkably versatile and, when mastered, can be used to create an astonishing variety of marks, effects, and textures.

This chapter will introduce you to the tools and techniques that I've used as a professional comic book inker. You will begin with some basic but crucial exercises to develop your skills and your understanding of how the nib and the brush behave. These lessons will become increasingly complex and enjoyable. But first, here are the tools you'll need.

PEN NIBS

Illustrators, calligraphers, and comic book artists use pen nibs almost exclusively. Although there used to be numerous manufacturers of pen nibs, the only American company still producing the crow quill variety of nibs is Speedball. The nibs are still referred to as Hunt nibs by most artists, after the C. Howard Hunt Pen Company, which created the nib. (The barrel of every nib still bears the original manufacturer's imprimatur.)

Speedball sells an inexpensive sketching project set that contains six different pen nibs and two penholders. If you have never inked with a nib before, this is the best and most economical way to get started. The set allows you to experiment with a range of nibs that vary in size and flexibility.

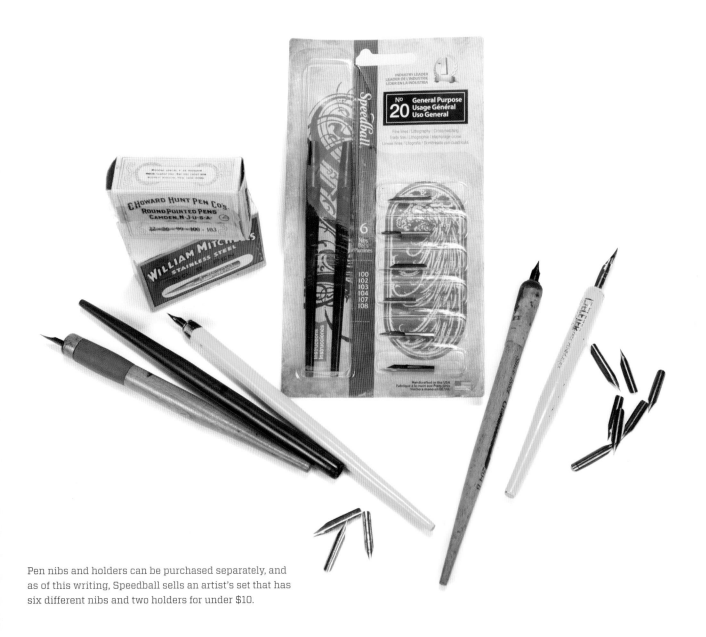

Pen nibs and holders can be purchased separately, and as of this writing, Speedball sells an artist's set that has six different nibs and two holders for under $10.

Two Japanese companies, Tachikawa and Deleter, also sell three excellent nibs: Maru, G, and Saji. These nibs are well constructed and have a very long life span. The Maru pen is similar to the Hunt; it has a very sharp point that is capable of making a very fine line and is flexible enough to produce a wide variety of marks and line widths. The G pen is larger but is capable of making lines as fine as those made with the Maru nib, and it is virtually indestructible. I've used the same G nib for over six months; most of my Hunt 102 nibs lasted only a week, at best, before they lost their flexibility and fine line. The Saji nibs have a spoon point, which means the tip is rounded; most nibs have a very sharp point. This spoon point makes it easy to make marks in any direction, but it tends to have a slightly thicker line. Several pen manufacturers make nibs with spoon points, and they all work perfectly with whiteout.

The inner circle of this nib holder is for cylindrical nibs; the outer ring holds broad barrel nibs.

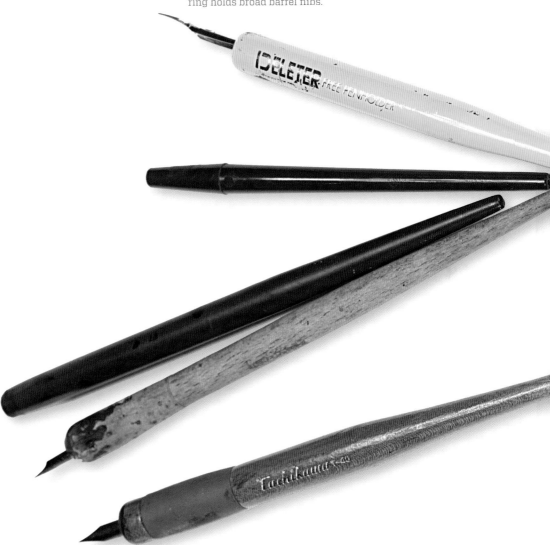

Pen nibs have two types of barrels: cylindrical (Hunt 102 and Maru pens) and broad barreled (Hunt 108 and G pens). The holders are cheap (around $1), and the Japanese companies make a universal penholder for both types of nibs.

Try using different nibs to ink the same subject to get a feel for how each nib reacts and behaves. Firm nibs are great for clean line work, but it might be best to use a flexible nib to create a gritty surface texture. The only way to know what works for you is to experiment and practice using as many tools as possible.

WHY INK WITH A PEN NIB?

Here's a question many beginning sequential artists ask when they are introduced to a crow quill pen (a drawing pen that must be dipped into a container of ink to "load" it): "Why can't I use a Pigma Micron or some other mechanical pen?" It's a valid question. Many comic artists use them. They contain acid-free, archival ink and, because they can be held like a pencil, are easy to use. They're very convenient, are easy to carry, and are great for location sketching. I sometimes use them when inking pages—for certain things. These things include mechanical backgrounds and elements that require uniform line consistency. However, they are incapable of producing the varying line widths and the textured patterns and marks of a pen nib.

Reluctance to use a pen nib stems from being unacquainted with the tool. If you are unfamiliar with pen nibs, you may be confused about which one to use. After all, they come in an array of shapes and sizes, and the tips can be either firm or very flexible.

The best way to overcome your disinclination to use a nib is to avoid using any other tool to ink with for a while and make a habit of practicing every day with a nib. If you do this, your hand will adapt very quickly and you will feel comfortable using a nib in less than two weeks.

A FEW OTHER NECESSARY ITEMS FOR INKING

- A container for water to keep your pen clean

- A cotton rag or coffee filter to wipe away excess ink

- A pad of legal paper or an old magazine to use as a surface onto which you can shake out excess ink from the pen

- A straightedge razor blade or X-Acto knife to scrape away any dried ink from the nib

ANATOMY OF A PEN NIB

Pen nibs vary in shape, size, and flexibility. Drawing nibs can be identified by their sharp tips. Although any nib can be put to use as a drawing tool in the hands of a skilled artist, most broad-tipped nibs are used for hand lettering and calligraphy.

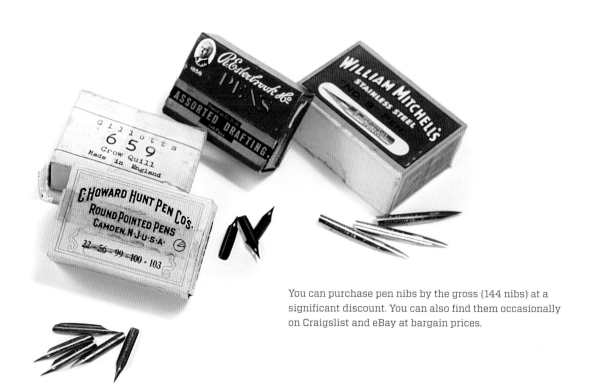

You can purchase pen nibs by the gross (144 nibs) at a significant discount. You can also find them occasionally on Craigslist and eBay at bargain prices.

THE STRANGE TALENT OF

LUTHER STRODE

JUSTIN JORDAN TRADD MOORE FELIPE SOBREIRO

A good brush, in the hands of a skilled artist, can produce lines as thin as those from a crow quill pen, and the only limit on its maximum width is the size of the brush itself. This highly detailed cover illustration was inked entirely with a brush.

BRUSHES

A good brush is an inker's best friend. It holds much more ink than a pen nib; this means that unlike a nib, you can use it for long uninterrupted periods. It can be used on almost any paper; it glides over the paper's surface and will not pick up tiny paper fibers the way a pen does. The brush is also capable of producing the greatest range of line widths.

CHOOSING BRUSHES

Although you can use any brush for some things, such as filling in large areas of black and creating special effects, your primary brush should be a genuine sable-hair watercolor brush. For the last fifteen years I've used either a Raphaël Series 8404 size 2 or 3 brush or a Winsor & Newton Series 7 size 2 or 3 brush for all my professional inking jobs.

A quality sable-hair brush is a result of great design, materials, and craftsmanship. It has several significant advantages over other brushes, one of which is crucial for comic book artists: it always comes to a fine point. That feature is worth its weight in gold. A big brush, such as a size 4, is capable of producing a line as fine and thin as that of a size 00 brush. A good brush also has a longer life span than do cheaper brushes, so don't be tempted by the lower prices. A novice inker should begin with a size 2 brush—a quality version Raphaël or Winsor & Newton can be found online for under $20.

ART SUPPLIES WEBSITES

The following websites are reputable and keep an extensive array of art supplies in stock. All of them run sales regularly, so it's a good idea to shop around before purchasing materials.

- www.dickblick.com
- www.utrechtart.com
- www.pearlpaint.com
- www.jerrysartarama.com
- www.amazon.com

PURCHASING BRUSHES

Although most high-quality sable-hair watercolor brushes come to a fine point, there are occasional duds. Purchasing brushes online almost always saves you money, but I order at least three when I buy them from a website. Most of the time all three brushes are excellent, and on the rare occasion when they aren't, I have never received more than one defective brush in any single order. All the large and reputable stores have return policies that allow you to exchange defective items free of charge, and they pay for the return shipping.

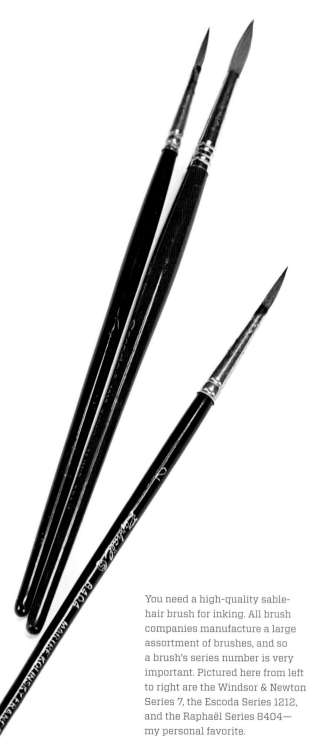

You need a high-quality sable-hair brush for inking. All brush companies manufacture a large assortment of brushes, and so a brush's series number is very important. Pictured here from left to right are the Windsor & Newton Series 7, the Escoda Series 1212, and the Raphaël Series 8404— my personal favorite.

The greatest advantage of purchasing brushes from a retail store is that you can test them. Bring a bottle of water and your sketchbook (which you should always have with you, right?) to the store. Let a salesperson know you would like to test a few brushes. Most art stores keep them locked up or behind the counter to prevent them from being stolen—because of their size (small) and relative cost (higher than most other brushes). Dip the brush in your water until the bristles are saturated and then roll it on a piece of paper, rotating it as you pull it downward, until most of the excess water is gone. The brush should come to a fine point. Make a few test marks to confirm that it does not lose its point immediately. If it doesn't, you know you have a good brush.

MAINTAINING AND CLEANING BRUSHES

A good brush can withstand thousands of working hours, if you clean and maintain it properly. Never, ever leave a brush sitting in a container of water. It will misshape the brush's tip, and excess water can get caught between the wooden handle and the metal ferrule, causing the handle to become unstable or split.

Dip and swirl your brush in a container of water every twenty minutes and wipe it off on a cloth when you're at the drawing table. This prevents ink from drying out near the ferrule of the brush, which makes it harder to clean later and can prevent the brush tip from coming to a fine point. When you have finished with the brush for the day, rinse it out with cold water.

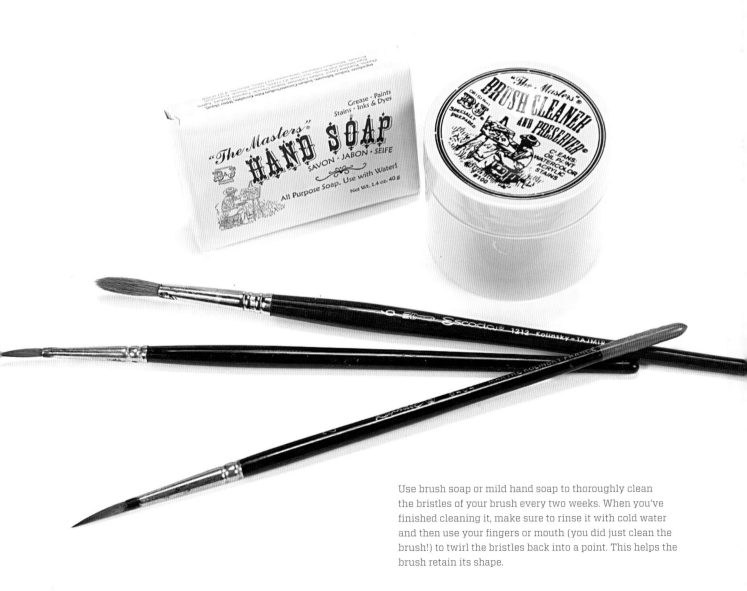

Use brush soap or mild hand soap to thoroughly clean the bristles of your brush every two weeks. When you've finished cleaning it, make sure to rinse it with cold water and then use your fingers or mouth (you did just clean the brush!) to twirl the bristles back into a point. This helps the brush retain its shape.

INK

You'll also need to purchase waterproof black ink (it is often labeled India ink) to use with your brush and pen nib. There are several types of ink on the market and just as many brands.

When choosing ink, consider its opacity and viscosity. What you choose depends on the tool you will be using. Opacity is easy to determine: if your ink is a uniform, deep black, then it is very opaque; if it contains different shades of gray when it dries, it isn't. Viscosity is mostly determined when ink is used with a nib. If it doesn't flow freely from the nib, the ink is too viscous. To thin it out, add a little water to your ink, or switch to using a brush for the thicker ink. When you use a pen, you need a free-flowing continuous line. If your ink is too thick, it will get clogged in the nib, disrupt your lines, and lead to frustration. A thicker ink is needed for the brush. A brush is often used to fill in large black areas, and thinner inks will dilute and create gray, washed-out areas.

Really almost any ink will suffice for a pen. If you buy a brand of ink that's too thick, you can just add some distilled water to it and dilute it to your liking. Higgins standard drawing ink has the advantage of being sold at almost every local megastore (in the stationery or arts-and-crafts section), so it's readily available to everyone. But while this ink works great with pens—it flows from the pen freely and makes a nice dark line—it tends to wash out and create areas of gray when used with a brush, particularly if you have to erase a penciled underdrawing.

You have to be more selective when buying ink for brushes. The ink needs to be both opaque and resistant to dulling when an eraser is used on it. Holbein has an excellent Special Black variety that flows freely and produces a lush, deep black. The only drawback is that you can only find it at specialty art stores or online, and it's pricier than most. Higgins' Black Magic and Eternal ink varieties are thicker than drawing ink and work well with the brush.

Koh-I-Noor sells Universal Ink for its Rapidograph pens, and it works well with both nib and brush. I've heard other professionals say that something in the ink's formula is more corrosive than other inks so it has a tendency to shorten the life of a brush, but I've never noticed this.

Many large online art stores are now producing art supplies and materials of their own. Like generic items in a grocery or retail store, they are usually cheaper and the difference in quality is minimal. The best way to find ink that works for you is to read online reviews and order a few small bottles (you can usually find them online for under $5) with which to experiment.

I use two containers of ink on my drawing table. One container holds pen ink, and the other ink for brushes.

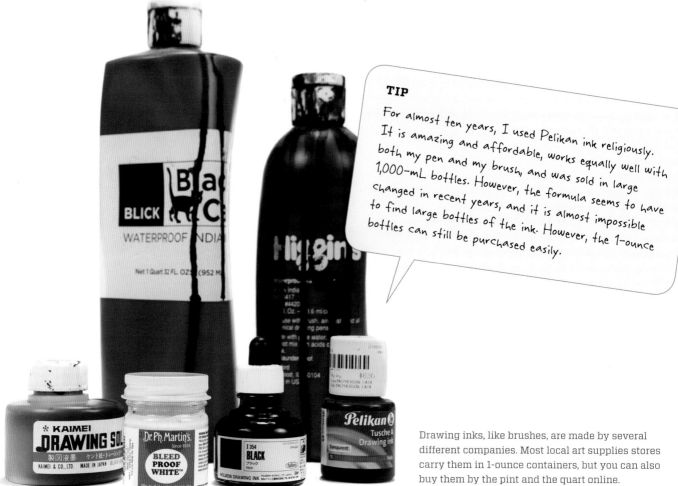

TIP

For almost ten years, I used Pelikan ink religiously. It is amazing and affordable, works equally well with both my pen and my brush, and was sold in large 1,000-mL bottles. However, the formula seems to have changed in recent years, and it is almost impossible to find large bottles of the ink. However, the 1-ounce bottles can still be purchased easily.

Drawing inks, like brushes, are made by several different companies. Most local art supplies stores carry them in 1-ounce containers, but you can also buy them by the pint and the quart online.

WHITEOUT AS A DRAWING TOOL

Most people think of whiteout as an inking eraser, something used solely to correct mistakes. However, whiteout can be used in many ways: to create patterns, to thin lines, to add designs into black areas, and to create halos around characters or objects.

I prefer Dr. Ph. Martin's Bleed Proof White, an opaque, bright white watercolor. Its consistency when the bottle is first opened is fairly thick, but perfect for use with the brush. It usually takes only one stroke to cover an ink line. If you want to use it with a pen, you'll need to add some water to it. Rather than adding water to the entire bottle, mix a small amount in a separate container. I keep two containers of white: one for use with a pen and one for with brush.

When using whiteout with a pen, lettering nibs with bowl points, such as the Hunt #512, are preferable. These nibs have a fine line but can be moved freely in any direction without tearing the paper.

TIP

If you leave the cap off of whiteout overnight (and trust me, everyone does this at some point), it will harden into a thick paste. Don't throw it away. All you need to do is add some water to it incrementally and stir it with the handle of your brush or a chopstick until it returns to its original consistency.

Whiteout was used on the trees after this image was inked
to increase the contrast between the trees and the house.

PAPER

Unlike pencil drawings, which you can make on any unlined paper available, inked pieces require high-quality paper because sharp pen nibs tend to tear into thin, inexpensive paper. Most American comic book artists use 11-inch by 17-inch sheets of Bristol board when they ink pages or covers.

Bristol board has two options for surface texture: plate and vellum. Plate paper has a very smooth glasslike surface and is ideal for both pen nib and brush. The vellum surface, also referred to as "kid" finish, is slightly "toothy" (it has a raised surface like a very fine sandpaper); this allows for some inking options that can't be produced on a slick surface. For example, it is much easier to create a greater range of dry brush textures on vellum than on a smooth surface.

Several companies manufacture Bristol board that includes printed blue line guides with rectangular margins for the live, crop, and bleed areas. They also have vertical and horizontal rulers printed along the paper's edges to ensure that panel borders are easy to place and that panel gutters are a uniform size.

In addition to the choice of surface textures, most companies make different "series" of their paper. The lower numbered series' papers are cheaper in both price and quality, but they are a good option for beginners to practice on. The 300-level series boards are

Many companies now make Bristol board specifically for comic artists, and it is precut to the standard 11-inch by 17-inch size. Some companies, such as Pro Boardz, will send you samples of their paper if you write to them and request it. (For more information, visit the company website at www.bcemylar.com/CAS/artboards.cfm.)

durable enough for most professionals. The 500-level boards are superior in every way, (and include a "semismooth" option that has a very slight surface texture), but they cost almost three times as much as the 300-level boards.

However, there are other economical alternatives for novices looking to hone their skills. Any drawing or sketch paper that is more than 70 pounds will hold up to a pen nib. Borden & Riley makes Bleedproof Paper for Pens, sold in pads with 40 sheets of paper, for about $10. Canson sells a mixed-media sketchpad with 60 sheets of paper for around the same price. I've also used 32-pound laser print paper to good effect for classroom

presentations, and you can buy a ream (500 sheets) of this paper for approximately $15.

You should experiment and work with as many paper surfaces as possible: hot- and cold-pressed watercolor paper, vellum, illustration board, and so forth. Every paper has unique characteristics and will react to ink and tools differently. Gaining an understanding of these idiosyncrasies and the potential effects you can create by harnessing them will pay big dividends later.

Bristol board is fairly expensive at about $1 a sheet. Both Canson and Borden & Riley sell sketchbooks and pads of paper that can withstand a nib's tip and cost only about $10 for 60 sheets of paper—perfect for practicing and improving your inking skills.

Pen Inking Techniques

Observing, drawing, and inking objects from life will help you improve your skills quickly. Many young artists believe that if they aren't drawing from their imagination, they're "cheating." Nothing could be further from the truth. Drawing and inking from life will help you understand how things are constructed and how light plays across different surfaces.

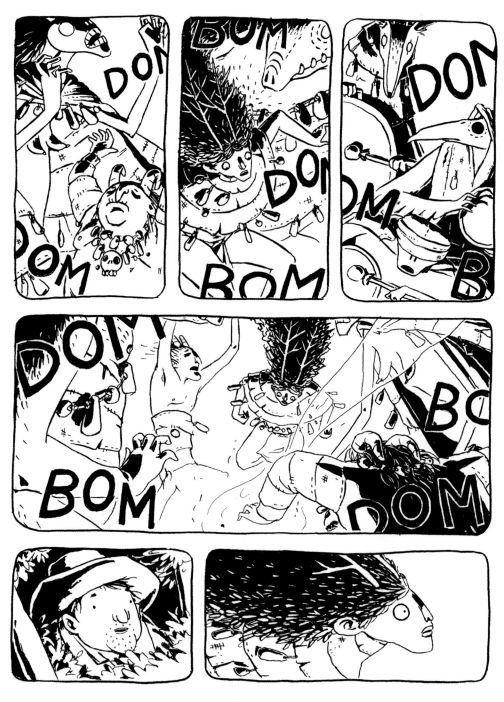

This illustration creates an interesting balance between delicate pen lines and bold black areas. A pen nib was used to create all the lines and textures on this comic page; a brush was used to fill in the large areas of black.

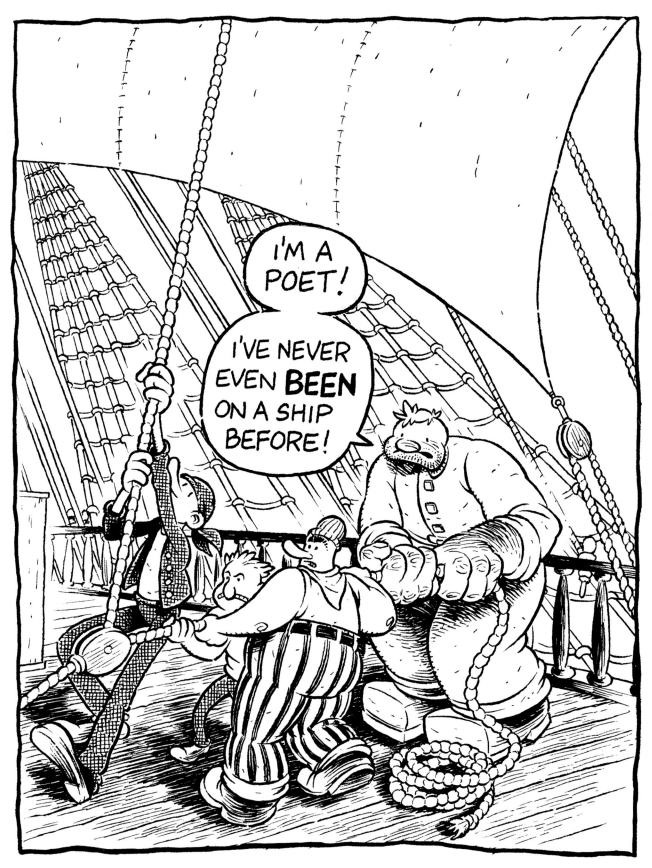

The values in this illustration were made exclusively with pen strokes.

FUNDAMENTALS

Remember, if you have never used pen nibs before, the best way to familiarize yourself with them is to play around .

Take out a piece of Bristol board and begin making marks. The beauty of using Bristol board is that it is thick enough that you can use the back for practice without worrying about it being seen from the front.

Try drawing straight lines and curved lines, moving the nib in different directions, and changing the pressure on the nib while making a line to see how it affects the line's shape and width.

Each nib has individual characteristics. Some produce very fine lines but are very sharp, which means you have to rotate the penholder in your fingers if you change the direction of the line; some move freely in any direction but may not be as flexible or have the ability to make a very fine line; other pens are very flexible and can produce a wide variety of marks but may be difficult to control in areas where precision is needed. You can think of very flexible nibs as metal brushes, meaning their tips open up very quickly, creating a thicker line when you apply a slight amount of pressure. Firmer nibs require much more pressure to create a line that may be only slightly thicker than the original line.

The bold and gestural areas of black in this comic page were made with a brush. All the thin lines were made with a nib, and the artist chose not to use a ruler when inking the structural elements in the page.

A TYPICAL WORKSPACE FOR INKING

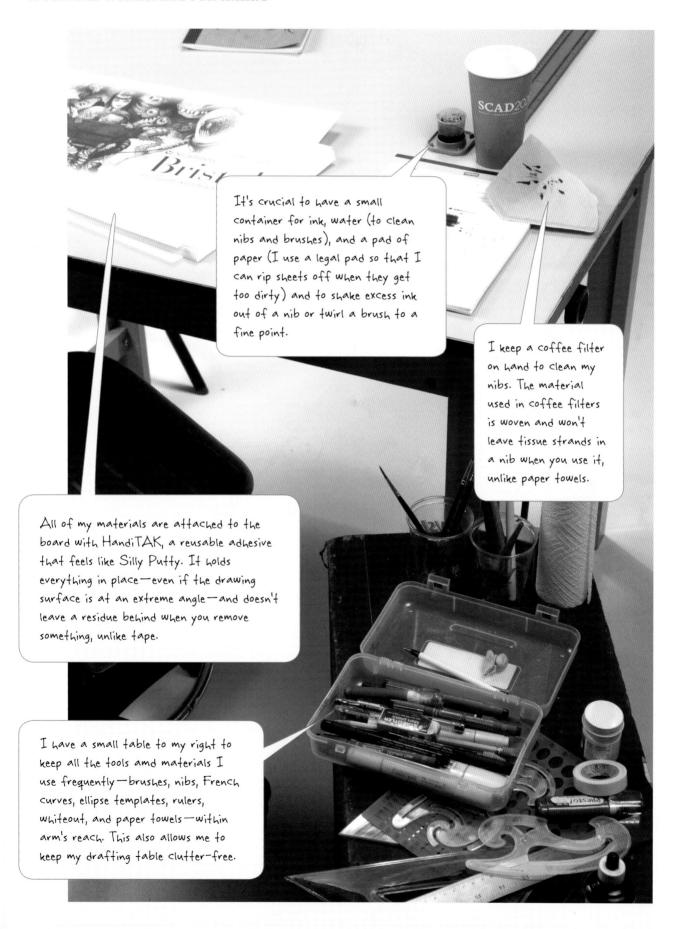

It's crucial to have a small container for ink, water (to clean nibs and brushes), and a pad of paper (I use a legal pad so that I can rip sheets off when they get too dirty) and to shake excess ink out of a nib or twirl a brush to a fine point.

I keep a coffee filter on hand to clean my nibs. The material used in coffee filters is woven and won't leave tissue strands in a nib when you use it, unlike paper towels.

All of my materials are attached to the board with HandiTAK, a reusable adhesive that feels like Silly Putty. It holds everything in place—even if the drawing surface is at an extreme angle—and doesn't leave a residue behind when you remove something, unlike tape.

I have a small table to my right to keep all the tools amd materials I use frequently—brushes, nibs, French curves, ellipse templates, rulers, whiteout, and paper towels—within arm's reach. This also allows me to keep my drafting table clutter-free.

INKING WITH A PEN NIB

This exercise is designed to help you explore a nib's versatility and begin to train yourself to control lines. After creating a series of squares, you will begin to fill them in with a series of lines and marks. Each line should begin on one side of your square and end on the opposite side. Try not to allow the inked line to end before touching the square's border and try not to extend the line past it.

Most important, do not rush your line. I have seen students who think the line will be straighter, cleaner, and more confident if they make a quick stroke. This is a mistake. It is better to take your time, even if the line wobbles or falters. Your lines, along with your confidence, will improve over time; trying to speed through this or any other exercise never helps.

- Draw thirty-five 1-inch squares on a sheet of Bristol board. Leave at least a half inch between squares.

- Scan the page after you have completed this; it will serve as a digital template for future exercises.

- Look at examples on the opposite page and try to replicate the lines and patterns.

- Create your own patterns after you have completed this exercise.

- Try using a variety of nibs for the exercise. Not only is it good practice, it will help you identify the nib or nibs that work best for you.

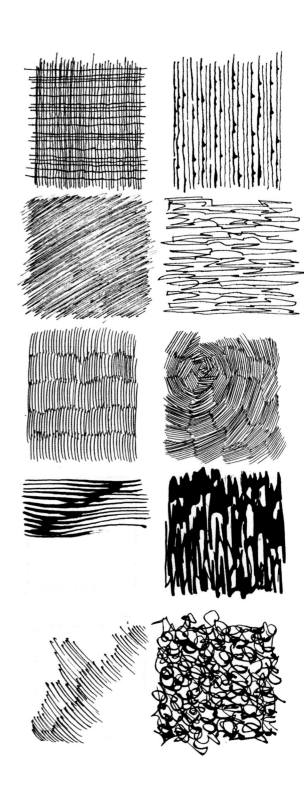

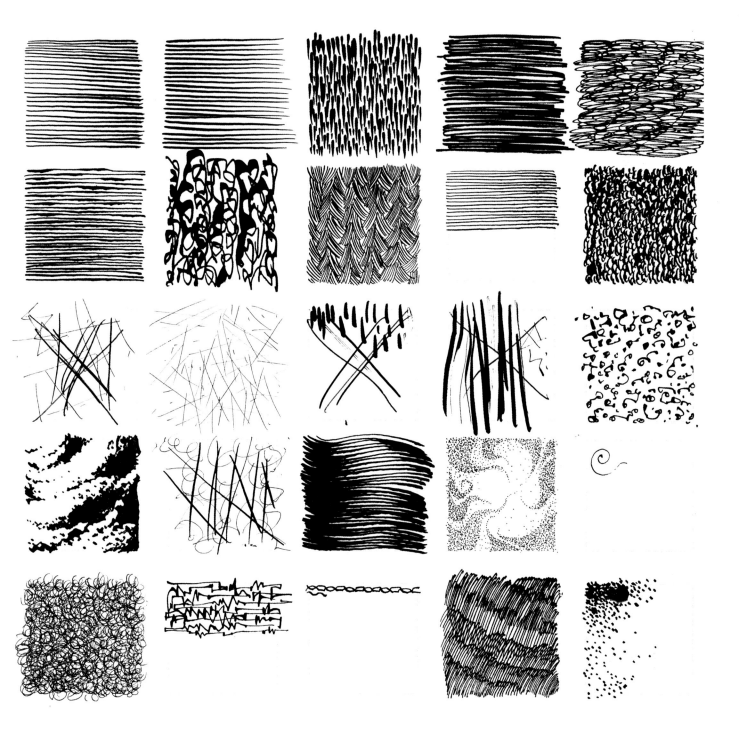

CREATING VALUE WITH LINE

Line defines a person or object's shape, and value defines its form. *Value*, when used in the context of art, is defined as the relative lightness or darkness of a surface. Creating areas with value in a drawing that is primarily linear produces depth and prevents a drawing from looking flat. Note: *tone* and *value* are the same in this context.

Some media, such as charcoal and drawing pencils, are relatively easy to manipulate to create a broad range of values. Simply apply more pressure if you want a darker line, and use an eraser to lighten the value if you find that an area is too dark. Ink is solid black, so lines and marks have to be built up to create successful value transitions.

Creating a few value scales is the best way to practice and to understand how to create tonal transitions. There are two basic approaches to creating value scales: stepped and continuous.

For stepped value scales, the lightest value is at one end of the scale and the darkest value is at the other end.

A continuous value scale is created inside a long rectangle. The transition from dark to light is smooth and subtle. The examples on the opposite page were created within a series of 1-inch boxes and use different mark-making approaches to create a complete tonal range.

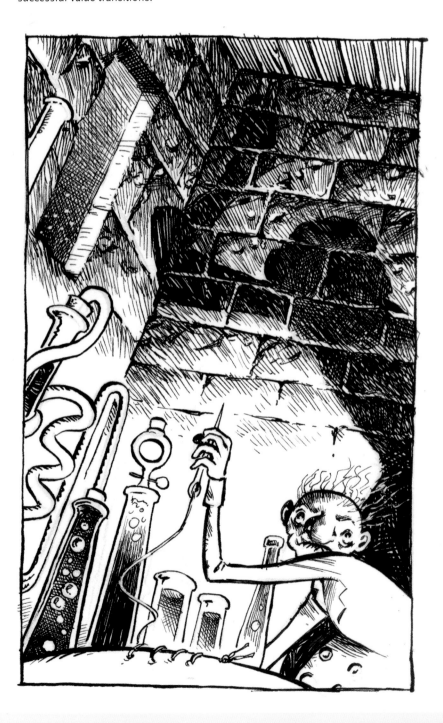

This inked drawing demonstrates the range of textures and values you can create using a nib. Study the variety of marks used to create different surface textures: wood, stone, glass, etc. Note how the value range transitions from light (at the bottom of the drawing) to dark (at the top, and most dramatically, in the cast shadow), creating the illusion of light.

Stepped value scales use a series of uniform-sized boxes, usually either five or ten. For comics, a five-step value scale is sufficient. That is because a five-step scale creates the illusion of a full value range on the printed page.

This continous scale uses organic cross-hatching.

This continuous scale was created primarily through the use of vertical lines. The pressure on the nib was increased as the artist went down the scale, and the marks were placed closer together as the artist moved from light to dark.

This continuous scale was made with horizontal lines. The pressure on the nib was increased—creating thicker lines—as the artist moved from the top of the scale to the bottom.

— **TRY IT** ————————————

Create three to five of your own stepped and continuous value scales.

CREATING TEXTURES AND SURFACES

After you've become comfortable with the pen and with the techniques covered earlier in this chapter, it's time to start applying those skills and approaches to real-life subjects and compositions.

You can use tone to provide a realistic distribution of light and shadow; you can also use it to create interesting monochromatic compositional designs through the distribution of areas of black, white, and gray. Both of these approaches are beneficial, especially when you learn to ink.

Working from observation and trying to re-create the various textures and surfaces of different objects (wood, glass, metal, fur, etc.) will require you to examine your subjects thoroughly and experiment with mark-making and the ways in which you can combine those marks.

Drawing and inking objects from observation is instructive and a great way to get accustomed to using your pen in different ways. Although comic illustration for the most part doesn't adhere to naturalistic styles (instead relying on design, pattern, and a good distribution of black, white, and gray). Drawing and inking everyday objects is always a good idea. You are more likely to experiment with your inking tools if you aren't focusing on perfecting your comic book pages.

Everyone has a preconceived idea about how his or her comic illustrations should look, and this often inhibits experimentation, which prevents discovery. When you understand the full range of marks a nib is capable of making, and get accustomed to making those marks yourself, new discoveries will find their way into your comic book work.

— **TRY IT** —————————————————————

Take an object, light it with a single light source, and spend no more than ten minutes making a good linear construction drawing in pencil. Complete the drawing with pen and ink. Make a few of these studies and use a different nib for each one. This will to teach you to draw with ink, and not just trace pencil lines.

The examples on this and the following pages demonstrate an array of pen inking approaches in working with diverse subjects.

Page 1

Continued...

This splash page (a comic book page comprised of a single image) was inked exclusively with a pen nib. Study it and note the ways in which a full range of values was created through marks, patterns, and line weights.

THE RAISED-RULER TECHNIQUE

Long, straight lines are often used to construct inanimate objects such as buildings, props, and vehicles. Artists often use T-squares and rulers when pencilling them. Pen nibs can also be used with rulers and, once again, have several advantages over mechanical pens: you don't need to switch tools to create lines with different widths, you can create line-width variations within a single line, and multiple lines can be inked without moving the ruler.

A metal ruler with a cork bottom is the best choice for inking with a nib. A nib can scratch and create divots in a plastic ruler, disrupting a neat line and rendering the ruler useless. A nib glides across a metal ruler, and the cork bottom creates a beveled edge even if you don't lift the ruler off the paper's surface.

However, becoming comfortable with lifting a ruler off the surface of the paper is important. Once you have become proficient with this technique, it can be applied to other tools, such as French curves.

TRY IT

Take three to five objects that have different shapes and surfaces and arrange them in an interesting composition. Make a linear pencil drawing, scan it, print out three copies on Bristol board (either vellum or smooth), and ink it. Concentrate on how you can use mark making to distinguish the objects you've chosen and create an illustration that is visually appealing.

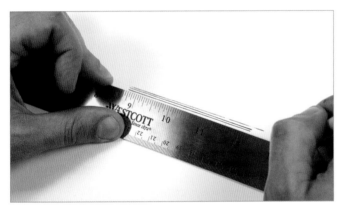

1. Begin practicing the raised ruler technique by laying your ruler on a piece of Bristol board. Place your thumb on the bottom of the ruler; this will prevent it from moving when you ink a long line.

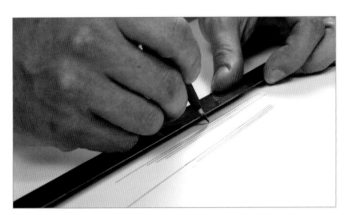

2. Lift the ruler with your fingers until the bottom metal edge of the ruler rests comfortably on the paper. I usually rest my index finger at the top of the ruler, between the ruler and the paper, to stop it from slipping up or down. After dipping your nib in ink, rest the barrel of the nib on the ruler's edge and pull a long straight line.

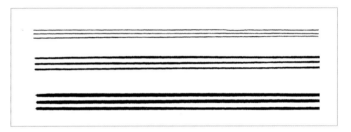

3. After you are comfortable with this technique, try creating lines of different but consistent widths by changing the pressure on the pen, as in the above examples.

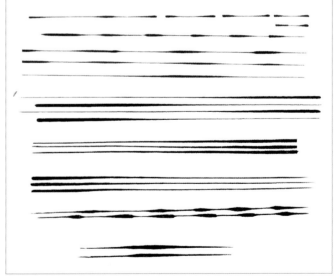

4. Now create a series of long lines, varying the pressure of the pen as you're drawing the line. Create lines that begin thin and get consistently thicker and lines that begin thick and get consistently thinner, by varying the pressure as you make the lines, allowing them to bounce and skip.

USING A NIB WITH A FRENCH CURVE

Once you are comfortable using a nib with a straight rule, you are ready to use it with a French curve. Most French curves are beveled, their outer edges are raised off the paper's surface, preventing ink from bleeding under when you ink with a nib. However, most curves are made out of plastic, so you must lift the French curve high enough to touch the nib's barrel. If you don't, you can easily chip a good curve and will have to replace it.

TIP
Beveled French curves are often labeled as having an "inking edge." An inking edge is the same as a beveled edge. Metal curves are more expensive, but they don't chip and will last a lifetime. However, they don't have a beveled edge. What to do? Get some superglue or tape and attach pennies to the bottom of the curve. You've just created a beveled edge!

The lifting technique you use with a French curve is identical to that used with a ruler. After finding the right curve for the line you intend to ink, place your thumb on the bottom of the curve and lift the opposite side with your index finger. If you feel more comfortable leaving the curve on your drawing surface, make sure to shake out the excess ink from your nib before you begin inking the line.

Brush Inking Techniques

The brush is probably the most versatile inking tool available. It holds a lot of ink (so you don't have to dip it in an inkwell constantly), it can produce lines that range from razor thin to incredibly thick, and because it doesn't gouge the paper's surface, it dries very quickly.

HOLDING THE BRUSH

For fine detail work or when you are working in small areas, hold the brush the same way as any other drawing tool—with your fingers positioned close to the brush's ferrule. This provides more control, but limits the mark-making range. However, when you want to make long sweeping lines, hold the brush perpendicular to the paper. The stroke will emanate from the arm, not the fingers and wrist. This takes some practice, but the sooner you begin,

the sooner you will become comfortable with it. Mastering this technique augments your set of skills and provides unique inking possibilities.

Before you begin, clear everything from your drawing table except ink, water, and a piece of paper. You don't want anything to interrupt your brushstroke, as one of the biggest advantages of this technique is that you can make very long lines. Place your elbow on the table first (it will serve as a fulcrum, and it can't do that if it isn't resting on a solid surface). Lower your hand over the paper without touching it and make a few "ghost" strokes in the air over the paper, using your elbow as a pivot point. Position the paper to correspond to the natural sweep of your stroke. After doing that, lower your hand until your palm touches the paper and then lower the brush until it just touches the paper. Now lock your hand and fingers in place—they shouldn't move after you establish how thick

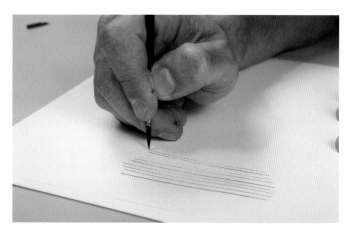

2. Lower your fingers until the brush just touches the paper. The fingers not holding the brush will be used to support your hand and prevent it from moving up or down, providing a consistent line.

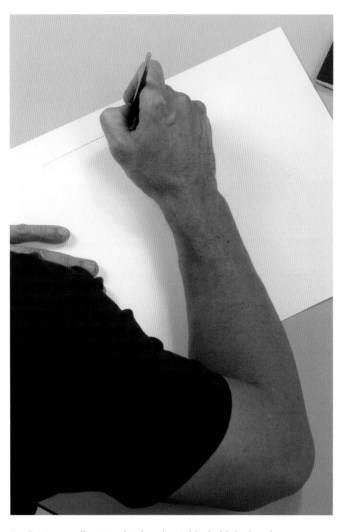

1. Rest your elbow on the drawing table, hold the brush perpendicular to the paper (this will seem awkward when you first try it, but it's critical), and lower your arm, allowing the palm of your hand to make contact with the paper first.

you want the line to be—and begin pulling a straight line using your arm. Your hand should never move up or down.

This always feels awkward when you first try it, and people's hand positions vary, but the one thing you have to keep in mind here is that the brush *must* be held straight up and down, perpendicular to the paper. I extend my pinkie finger for additional stability, but there isn't a single right way. If you have never inked this way before, don't worry about anything other than maintaining a consistent line width. Make thin lines, thick lines, and lines of any other widths in between. The brush is truly remarkable and capable of more line variation than any other inking tool.

Learning how to hold and control a brush is vital and isn't very hard. If you practice daily, you can master it quickly.

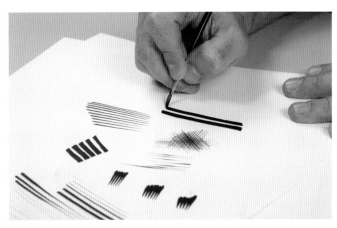

4. Play around with the brush. Here I'm holding the brush at a 45-degree angle while pressing down a lot. This creates a very thick line that has straight, square edges.

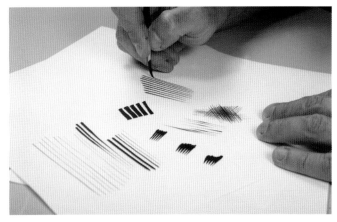

3. Pull a line across the paper slowly, focusing on creating a line of uniform length.

5. Create a thin to thick line by holding the brush at a slight angle and increasing the pressure while you make the stroke.

INKING WITH A BRUSH

When you have become comfortable with the brush, it's time to do some structured exercises. This exercise is identical to the pen exercise, as is its goal: learning to control the brush while discovering its unique characteristics and possibilities.

- Print out the series of 1-inch squares you created and scanned for the pen exercise on page 90.

- Bristol board is preferable but not necessary; a brush can be used on almost any type of paper.

- Look at these examples, try to re-create them, and remember, especially when using a brush, to make straight lines and to try to begin the line at one side of the square and end it when it touches the opposite side. Confident inking is the result of learning to control your tools. If you can make a consistent straight line with a brush, you can create that same line with any other tool you pick up.

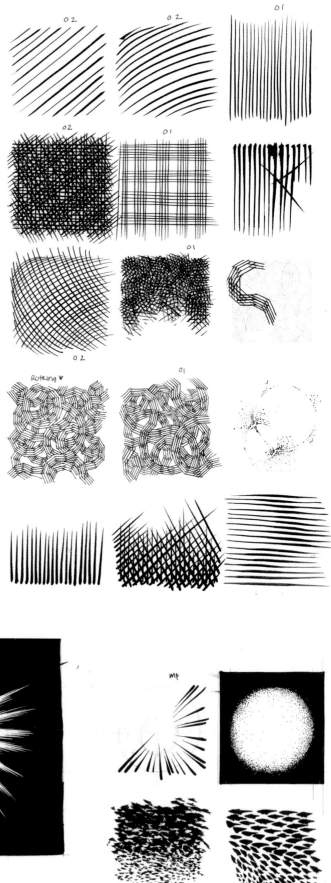

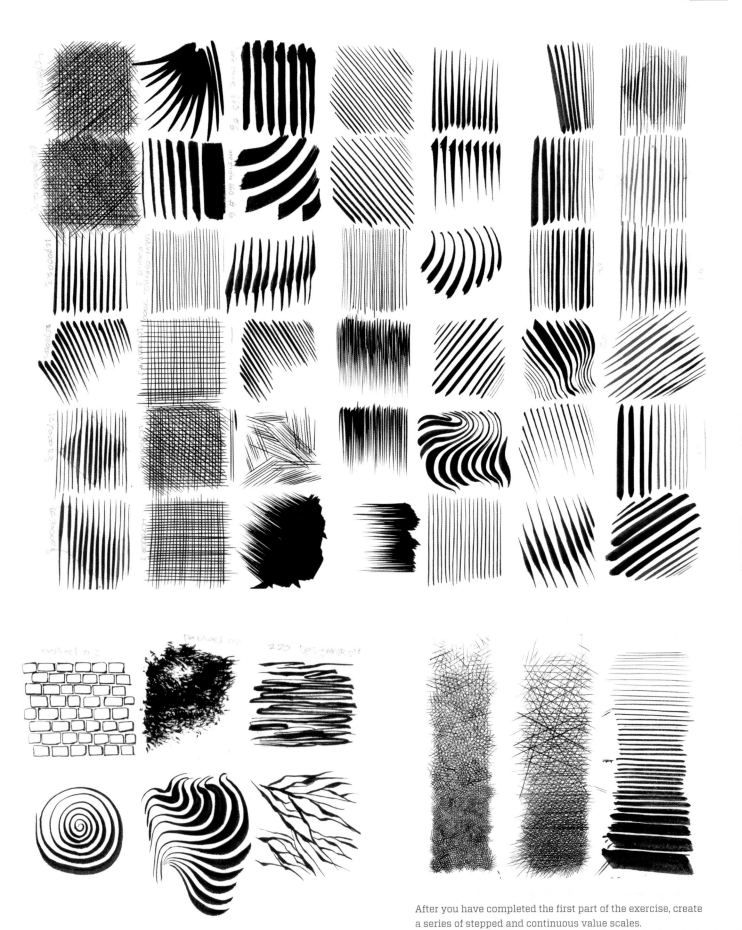

After you have completed the first part of the exercise, create
a series of stepped and continuous value scales.

CREATING TEXTURES AND SURFACES WITH A BRUSH

Trying to re-create the fine lines that a pen makes with a brush is challenging and will help you to master brush use. The brush is also capable of creating an enormous variety of marks that a nib can't. A sable-hair watercolor brush is capable of making more marks than any other inking tool. Load it up with ink and draw thick lines by pressing down on it, wipe most of the ink from the brush and create textures using dry brush techniques, and stipple with the brush, etc. Play with the brush on paper, and see how many different textures and marks you can make.

In the examples shown here, the artist uses a brush to interpret her composition in three unique ways:

--- TRY IT ---------------------------------------

Ink at least two of the objects that you initially drew for the pen studies with a brush (remember to always scan your pencil drawings).

Select new objects to draw and ink. Ask yourself what surfaces and textures lend themselves to the fluid lines and remarkable range of line widths that are unique to the brush. Play and experiment.

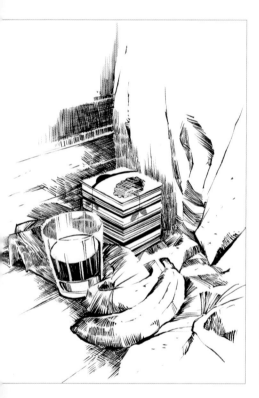

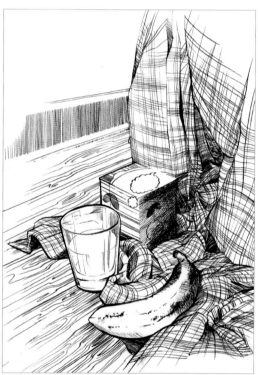

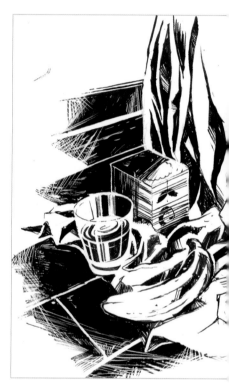

1. Concentrating on the relative values within the composition.

2. Emphasizing natural textures (the wood grain and the surface of the banana) and printed patterns (cloth and Kleenex box).

3. Creating a high-contrast, dramatic interpretation of household objects.

Right: This drawing was created using a variety of inking tools and techniques.

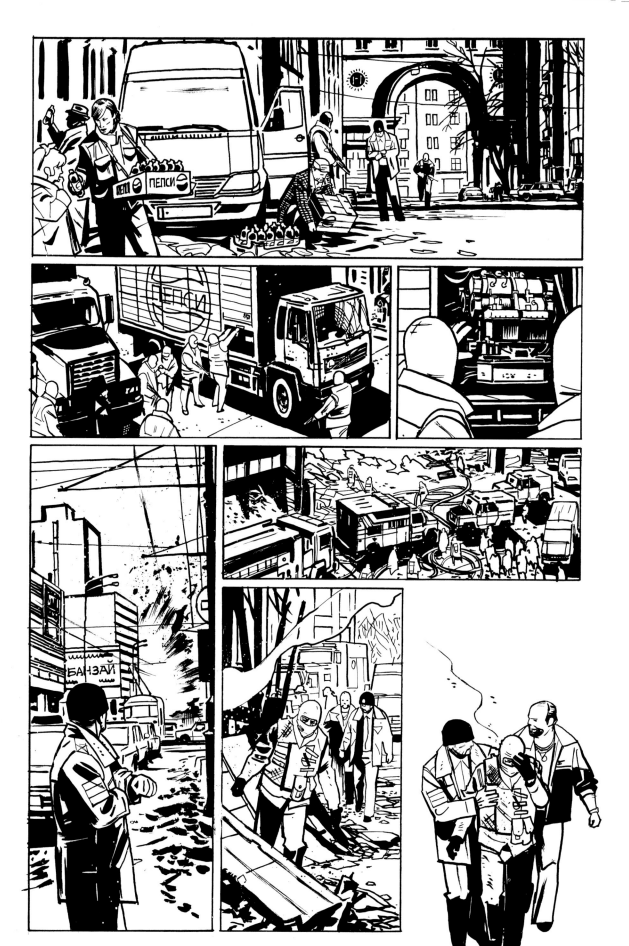

FEATHERING

Feathering is a great way to make transitions between black and white areas. It is often used by (but not limited to) "mainstream" comic artists and inkers to create a slick, professional look.

You should be able to quickly add this skill to your inking arsenal, as long as you have a good brush.

1. Dip the brush into the inkwell and bring it to a nice point by twirling it on a spare pad of paper. A good sable-hair brush will assume an inverted teardrop shape with a razor-sharp point.

2. Hold the brush at a 45-degree angle above the paper and, using your wrist, push down.

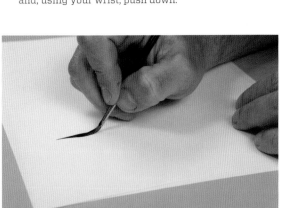

3. Pull the line toward you as it reaches its widest point.

4. You'll notice that the brush has made a nice thin to thick line with very little effort on your part.

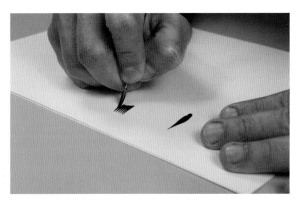

5. For practice, make a number of these lines side by side. As you gain confidence with this technique, make your lines longer. This technique can also be used with nibs and a raised ruler or a French curve if you need to make longer, converging lines.

DRY BRUSH

If a slick and smooth approach doesn't suit your style or if you want to create some interesting areas of contrast within your inked drawings, you may want to consider using the dry brush technique. This technique isn't difficult, but if you choose to use it extensively to create a full range of values, it requires patience and takes a while to master.

Dry brush techniques work best on vellum surfaces. The paper's "teeth" create hills and valleys, which cause the brush to skip along its surface. You should also experiment with cold-pressed watercolor paper; its surface is even toothier, which creates distinct lines and patterns.

This technique can be hard on your brushes, and so it's best not to use a new sable-hair brush for this approach. Use a cheap synthetic brush or an old sable-hair brush (never throw old brushes away) instead.

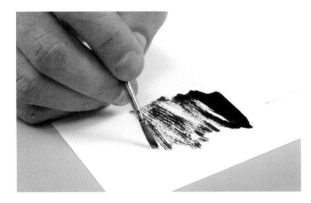

1. Remove most of the ink from the brush. It's best to use a vellum surface for this; it removes the ink quickly, and the uneven surface spreads the brush's hairs apart.

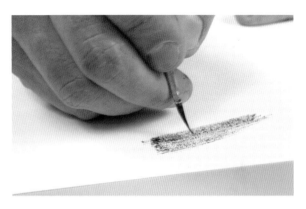

3. Denser, dark areas require several strokes.

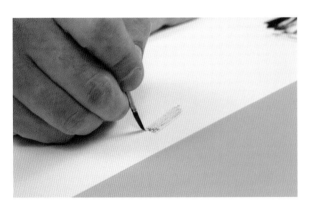

2. You can make your lines very dry and light if you remove almost all of the ink.

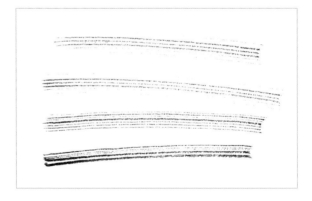

4. Each of these lines was made with a single brushstroke. Most of the ink was removed from the brush before the line at the top was drawn. Each successive tier contained progressively more ink.

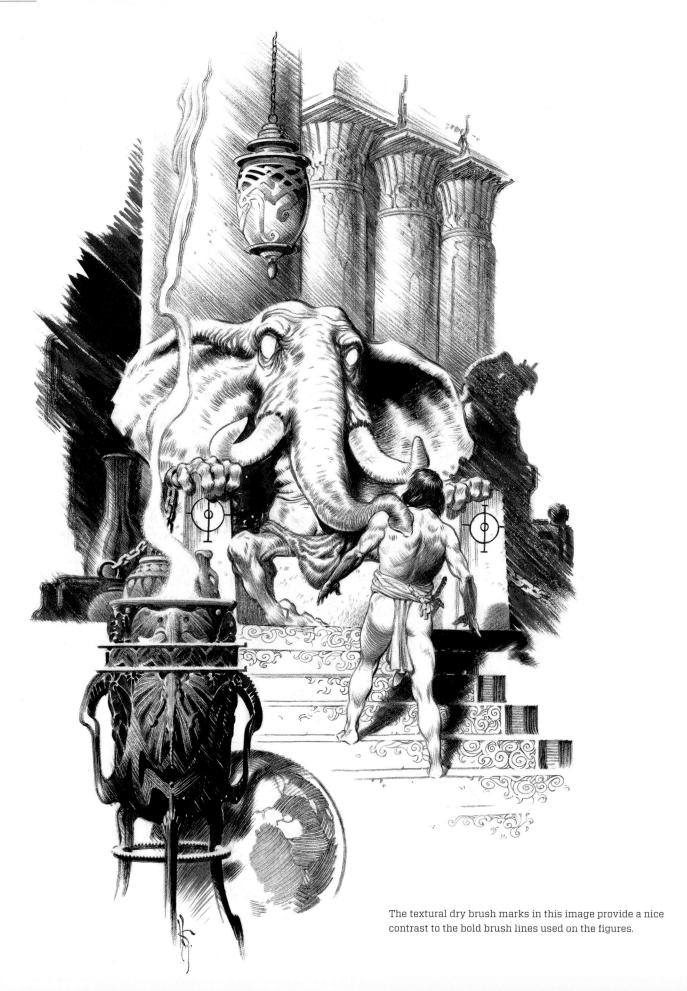

The textural dry brush marks in this image provide a nice
contrast to the bold brush lines used on the figures.

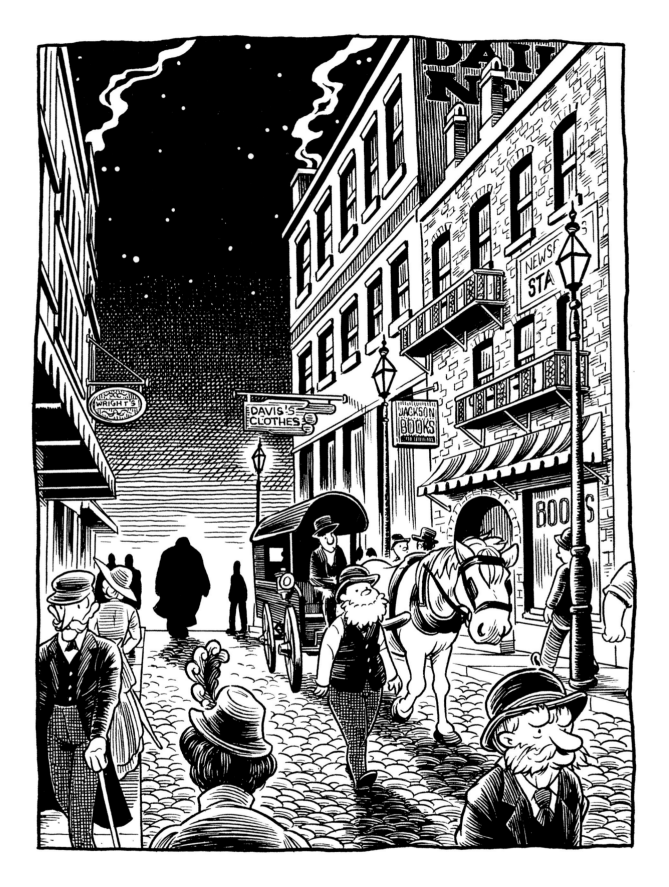

This comic panel demonstrates exceptional mark making and displays interesting textures, patterns, and transitions from light to dark areas.

7

ADVANCED INKING TECHNIQUES

Using Unconventional Materials to Create Unique Textures

Generally, you never use just one tool when inking. Both the pen and the brush have unique characteristics, and discerning artists utilize a combination of both to best depict their subject matter. Combining both tools increases the range of possibilities significantly.

Pens and brushes are a comic book artist's primary inking tools, but anything that can make a mark can be used. After all, as long as it leaves an impression on the paper, you can darken it in Photoshop or any of several other software programs to create solid black marks or textures.

Lithographic crayons, children's crayons, and soft graphite pencils can be used to create gritty surfaces. You can apply ink to many kinds of fabric, lace, and other materials and press them against your paper. Cotton balls, Q-tips, and sponges create distinct tones and textures.

You can also rub textures onto lightweight printer paper with a lithographic pencil, as long as the surface you're working with is firm enough to withstand the pressure. These marks can be scanned, adjusted, and easily applied to your illustrations with a software program. Once they're scanned, be sure to save and organize them so you can reuse them in the future.

A small doily from a scarf was dipped in ink and applied to this drawing to create the daffodils' textures.

A razor blade was dragged across the figure's wings in this illustration. This created organic areas of white and contrasts nicely with the graphic approach used for the figure.

Masking an Illustration

You can mask off simple shapes with bits of paper, and in a pinch you can use an X-Acto knife, printer paper, and a light box to create more complicated shapes. However, frisket film, a low-tack sheet of clear vinyl, is the best choice for masking off intricate areas.

It is always a good idea to mask areas off you don't want to be affected when you're working with materials that aren't easy to control—sponges, fabrics, sheets of plastic, and so forth.

Frisket is a thin translucent plastic film backed with a low-tack adhesive. It adheres to the paper but can be removed or repositioned easily, and it won't harm the paper or remove ink.

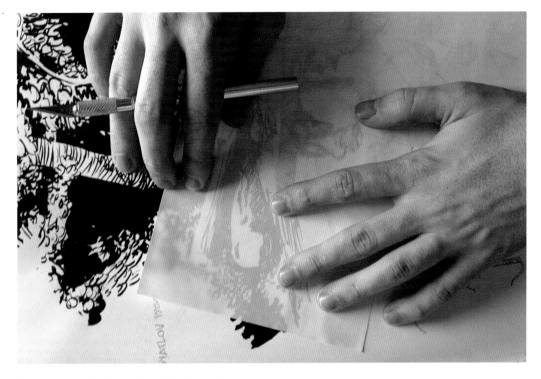

Take a sheet of frisket and position it over the area you want to keep clean. You can see through the sheet of frisket. Use an X-Acto knife or razor blade to cut out frisket matching the space you need to cover. Remove the film from the back of the frisket, apply it to the paper, and cut away any excess.

Now that the area is covered, you can pick up your toothbrush (or sponge, cotton, cloth, etc.) and apply it freely.

Lift the frisket off after the ink has dried.

I decided the tree limb looked too graphic in this illustration, and so I shook most of the ink out of the toothbrush and applied it to the trunk. When that dried, I took a razor blade and cut out organic areas of white.

X-Acto Knives and Straight Razors

You can use X-Acto knives to cut into paper and create a thin, organic white line within a black area (think concertina wire atop a prison's walls). Straight razors will also do the trick, and I prefer them because they are more durable and their points are less likely to break. A razor is ideal for reflective surfaces or when you need to create a picture that includes something exploding.

Note: You should always wear some sort of eye protection when working with a razor blade. Although it's rare, the tips can snap and fly into the air.

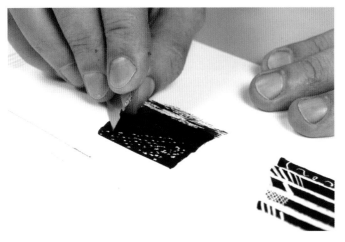

If you hold a razor blade at this angle and drag it across the paper, it skips across the paper, picking up divots of paper as it travels.

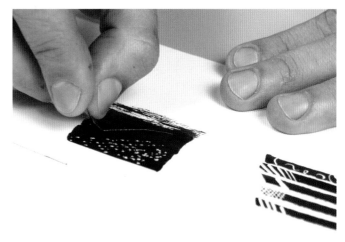

By reversing the angle, you can create an organic white line as you drag the blade across the paper.

Skipping the razor blade over the paper's surface created the divots on this page; the lines were created by dragging the blade along the surface.

Sponges, Toothbrushes, and Other Alternative Inking Tools

You can use anything that can be dipped in ink to make marks: sponges, toothbrushes, Q-tips, sticks, fingers, crumpled paper towels, and so on. Sponges are particularly useful and come in all shapes and sizes. You can cut or tear an old household sponge (or a new one if you're a spendthrift) into a few different shapes and sizes, and you can purchase an assortment of sea sponges in the pottery section at most art supplies stores. The marks a sponge makes depend on the sponge's consistency and the amount of ink you use with it. Generally, you'll want to remove most of the ink by dabbing the spouge on a scrap piece of paper before applying it to your piece.

You can also use items from the kitchen. What types of marks does a Brillo pad make? How about a dishrag? Crumple up some paper towels, napkins, and newspaper and dip them in ink. Experiment with varying levels of ink and see how many unique marks you can create.

Dentists recommend that you replace your toothbrush every three months to ensure proper dental hygiene. Don't throw them away! You can use them to create interesting splatter patterns. Just dip an old soft-bristled toothbrush in ink and tap it on a scrap piece of paper so that you won't drop a big blob of ink on your page.

When the excess ink has been removed, hold the toothbrush above the page and flick the bristles with your thumb. If you don't have gloves handy, use a butter knife or a ruler on the brush's bristles. If you want to create a smaller, more controlled splatter effect, try using a pen nib and a credit card. Just hold the card firmly in one hand and the pen nib in the other and flick the nib against the card.

If you don't mind getting your hands dirty, dip your fingertips in the ink, dab most of the ink off, and then use your fingertips on the page. It creates a unique texture that can be used for smoke effects, or to create a "gritty" surface.

If you're feeling really adventurous, pick up a stick or cooking skewer and try to ink a drawing with it. I've seen a video of Alberto Breccia, an amazing comic artist from Argentina, creating a beautiful ink drawing with a straightedge razor blade.

> **TIP**
> Q-tips can be used to cover large black areas quickly and extend the life span of a good brush. You can also use old brushes for this.

Apply a small amount of ink to an old toothbrush. If you have a bottle of ink with an applicator, you can use it to drop a small amount of ink onto the brush, or you can dip the brush in an inkwell and tamp most of it out on a separate sheet of paper.

Hold the brush in your hand and flip the bristles with your thumb. You can also drag it across an old credit card (or something similar) if you don't want to get your hands dirty. Try this a few times on a scrap piece of paper until you can control the range of the ink splatter.

Right: The smoke in this illustration was created by using the splatter technique and applying whiteout with the fingers.

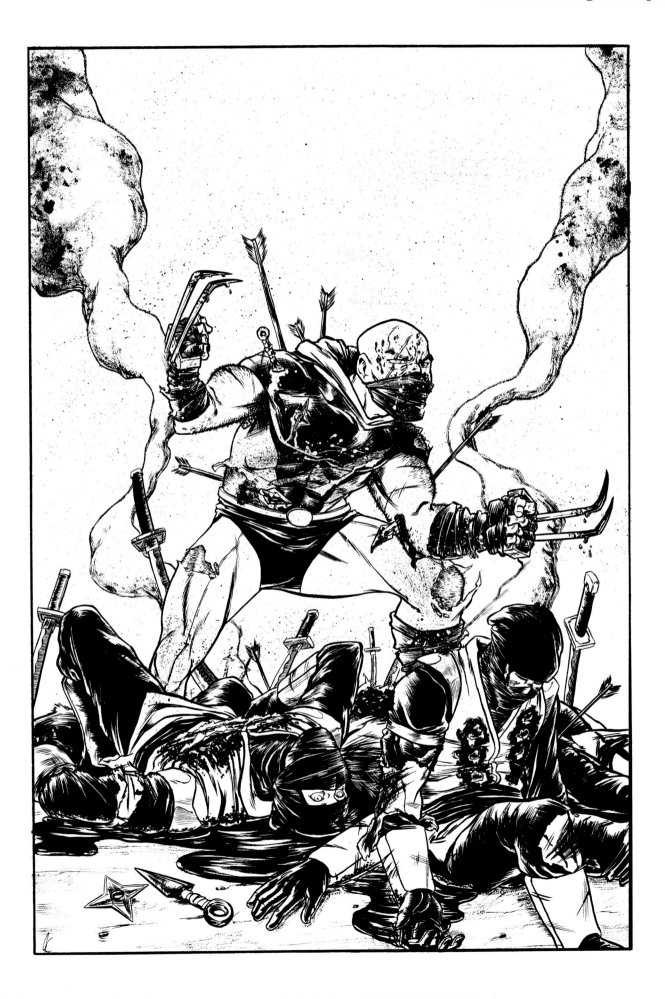

Black-and-White Design

Learning how to design in black and white and with tones improves your ability to see and create compositions that have a good tonal range. A well-designed black-and-white image will always look good, with color or without.

SCREENTONES

A screentone (often referred to as Zip-A-Tone) is a thin sheet of plastic film covered with halftone dot patterns or textures. The back of the film is coated with a low-tack adhesive such as frisket. The dot patterns vary in density and size, and there are hundreds of different patterns and textures on the market.

Screentones work particularly well with black-and-white comics and newspaper strips but rarely are employed in comics that use computer coloring; (as are most of the comics being published in the United States today. Screentone might have become obsolete if it weren't for manga comics). Most Japanese comics are still published in black and white and use screentones exclusively.

Black-and-white comics often rely on textures and patterns to enhance their visual appeal, but creating them by hand is a time-consuming process. Time is a commodity most working comic artists don't have—particularly manga artists, who often have to produce ten to twenty pages a week. Screentones cover large areas with patterns or textures quickly and enhance the artwork. The line work used by the artist can be more "open" and less detailed; this approach can save a lot of time.

The largest contemporary manufacturer of screentones is a Japanese company named Deleter. Thanks to the Internet, its products are easy to access and purchase. The only drawback is that at $5 to $7 per sheet, they're a little pricey.

A library of digital tones can be purchased for the price of a few sheets of screentone. It never needs to be replaced, it's tones can be applied with the computer, and a large tone collection is often included with some excellent computer software programs such as Manga Studio (more on this in chapter 8). If, however, you think of your pages as artifacts and plan to sell your original artwork, nothing beats the real thing.

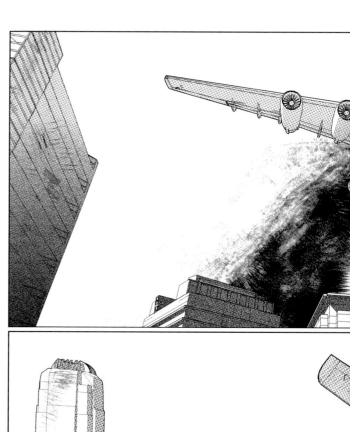

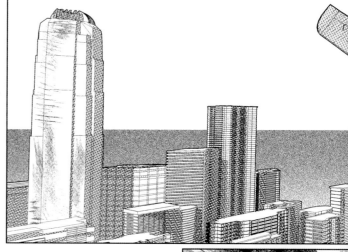

The digital tones make this energetic drawing even more visually interesting.

This incredible piece of art was created entirely with Manga Studio.

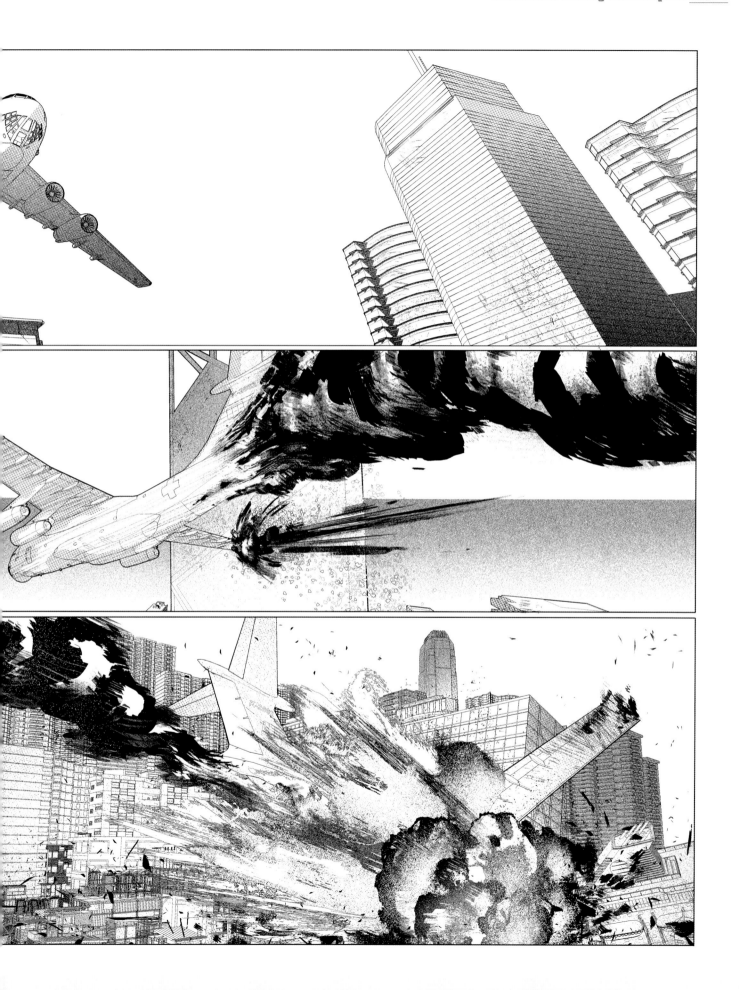

8

SOFTWARE APPLICATIONS IN COMIC BOOK ART

Creating a Grid in Photoshop

So you hate lining up your ruler with a perspective point every time you want to draw a line, or you don't have a table or ruler big enough to create a distant vanishing point. No problem. Adobe Photoshop can save you a lot of time and effort.

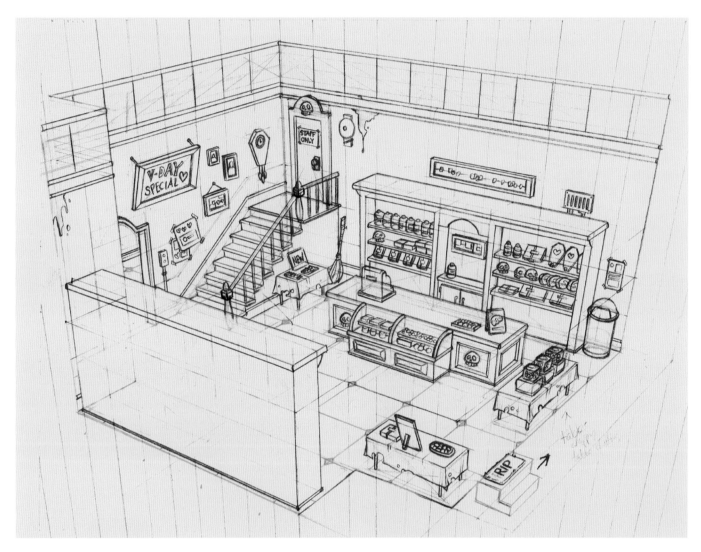

This complicated interior drawing was made by utilizing the principles of box construction and a grid for placement.

5. Click the mechanical wheel icon located next to the Sides window. Make sure to check the Star box and then type in 99 in the Indent Sides By box. Nothing else should be checked.

1. Open Photoshop and create a new 8.5-inch by 11-inch document. Go to the View tab and select Rulers from the drop-down menu.

2. Move the cursor over the ruler at the top of the page and drag down a blue line. This will be your horizon line.

6. You will find a Fill and Stroke window on the left-hand side of the same toolbar. Click each box and change it to the color of your choice. I prefer to use a blue line for the left vanishing point.

3. Select the Polygon tool from the Photoshop tool bar. The Polygon tool is located in Rectangle tool's drop-down menu.

4. When you choose the Rectangle tool, its preferences will be located at the top of the Photoshop window, above the ruler. Make sure that the Align Edges box is unchecked and change the number of Sides to 99.

7. Place the cursor at a point outside of the canvas on your horizon line where you want to place the left vanishing point (holding down the space bar and the command and option keys will allow you to shrink the canvas size). Click and drag the cursor, and radial lines will appear. Drag them until they extend through the canvas.

8. If the vanishing point is far away from the canvas, you can use the same tool again, placing it in the same location, and rotate it as you extend the lines. You can do this as many times as necessary. A new layer is created each time you use the Polygon tool.

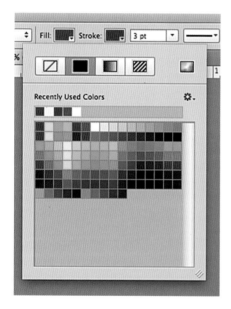

9. When you create the right vanishing point, click the Fill and Stroke boxes and change colors. Repeat these steps as necessary.

10. Click on the background layer and you will see your completed grid. If you don't see the layers window, go to the Window tab at the top of the screen and check Layers in the drop-down menu. Merge the layers: Layers > Merge Layers or Merge Visible.

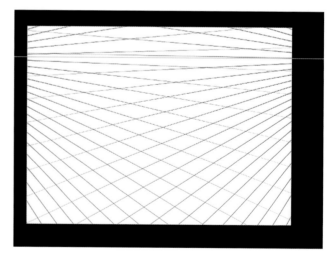

11. You now have a perspective grid to print out and use. You can create several of these grids quickly and save them as templates to use again and again.

CREATING A THREE-SIDED GRID
IN PHOTOSHOP

A three-sided grid will help you place objects and figures in space correctly. This particular grid method is one of the quickest and most effective ways to create intricate establishing shots.

Begin by using the same steps you used to create your first grid: create a new document, display the rulers, drag the horizon line down from the top ruler, and then select the Polygon tool and check

to make sure all its properties are correct. You don't need to change the color of the lines for this grid; you'll discard them later.

Create two vanishing points on the horizon with the Polygon tool. You need to use the Polygon tool only once on each side, but try to make at least one perfect square when you drag the lines out from the second vanishing point.

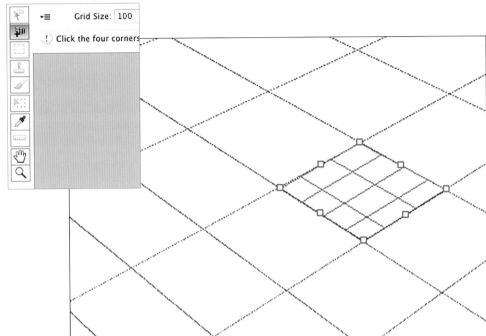

1. Once you've made the basic perspective grid, a new layer and then click Filter > Vanishing Point. A new window will appear.

2. Click the Create Plane tool in the upper left-hand corner of the new window and trace a perfect square by using the vanishing point lines. A blue anchor point and line will appear as you make the first box.

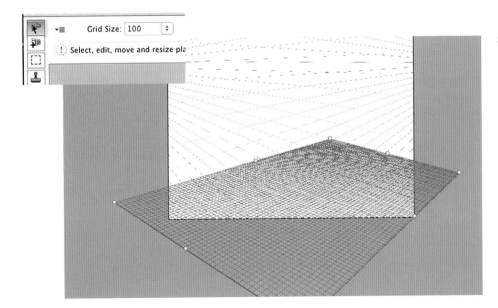

3. Click the Edit Plane tool (located directly above the Create Plane tool) and drag the midpoints of the square to fill the ground plane.

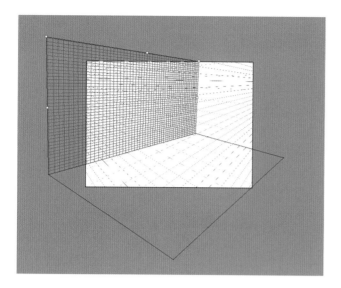

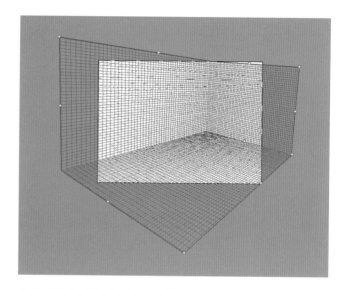

4. Switch back to the Create Plane tool and click and drag one of the midpoints from the initial square up. This creates a second, vertical plane.

6. Switch back to the Create Plane tool and click and drag the horizontal midpoint of your vertical plane. Select all the planes by holding down the shift key and clicking on three planes.

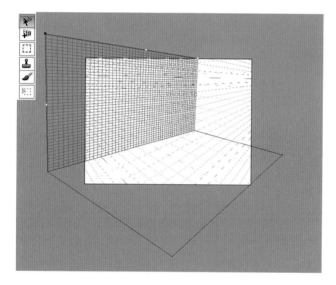

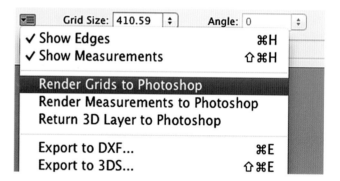

5. Use the Edit Plane tool to adjust the top right and left corners of the new vertical plane. Make the sides as straight as possible. If the lines on screen turn from blue to red, you have to adjust them until they are blue again. You can use the Edit Plane Tool only for the first two planes you create. It's a good idea to create planes that extend well beyond the canvas; this minimizes distortion.

7. With the planes selected, click the drop-down menu located beside the Edit Plane tool and select Render Grids to Photoshop. Hit the OK button in the upper-right hand side of the window. Delete your Polygon layers.

8. Use the Grid Size slide bar (located in the upper left corner of the window, to the right of the toolbar) to adjust the size and number of squares in the grid.

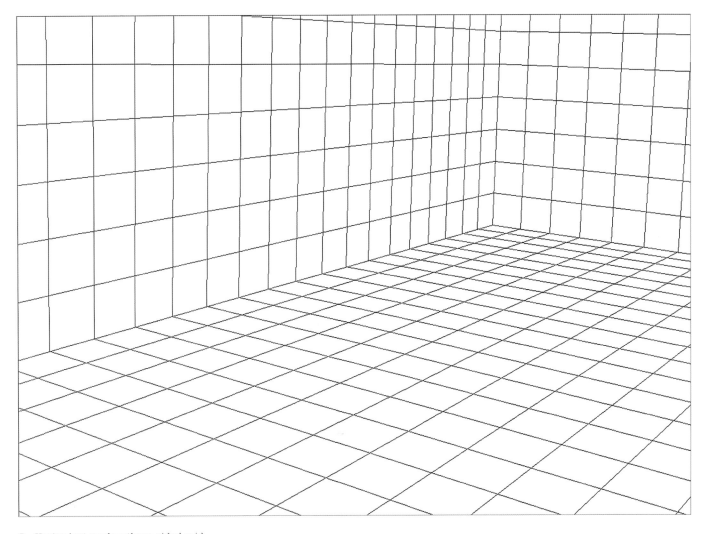

9. You've just made a three-sided grid.

── **TRY IT** ──────────────────

Create your own set of grids, using different horizon lines.
Create a grid file and fill it up.

Using the Perspective Tool in Manga Studio

The professional version of the art program Manga Studio (EX) includes several special perspective rulers that the regular version (Debut) does not. These rulers are well worth the slightly higher price tag. You can create small freehand perspective drawings, scan them, import them, and then complete your drawing. The rulers allow you to create a horizon line and use one, two, or three vanishing points. After you establish the height of the horizon line and create vanishing points along it, any line you draw will either be straight or recede to your vanishing points.

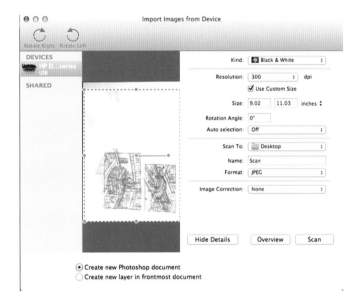

1. Create a freehand sketch using a grid you've created. Scan it in as a 300-dpi 8-bit greyscale PNG or JPEG image and save it to your desktop.

2. Open Manga Studio and choose File > New > Page. A window will pop up that allows you to customize the size of the new page.

3. Choose File > Import > Image File. A new window will pop up. If you don't see your image, locate the File Type box at the bottom of this window and choose "All image files" from the drop-down menu.

4. Select your drawing. A new properties window will open up. Two tabs are located in the top right of this window: Position Adjust and Image Adjust. Position Adjust allows you to change the scale or adjust the position of your drawing (you can also adjust the scale of the image by dragging the red anchors around the image). The Image Adjust tab has two tabs of its own: Layer Settings and Filter Settings. Filter Settings allows you to change the image's contrast or resolution.

5. Layer Settings allows you to rename your drawing. However, the most important step at this point is to make sure that the Color Model tab is set to Gray (8 bits). Occasionally, the program will import your file as a 2-bit grayscale file, and it will appear incomplete. When you reset it to 8 bits, the resolution clears up immediately. Click OK.

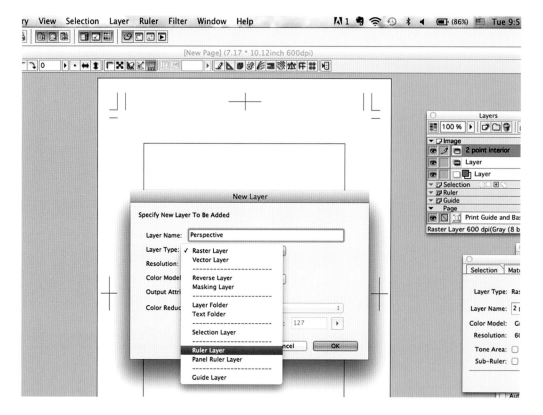

6. Click the Layer tab on the menu bar at the top of the screen. Choose New Layer. A New Layer window will appear. Name your new layer Perspective and choose the Ruler layer in the Layer Type drop-down menu. Click OK.

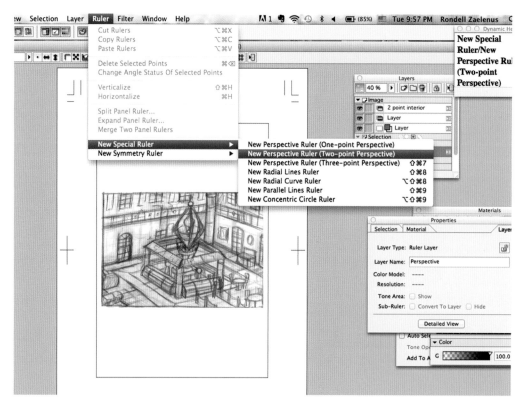

7. Click the Ruler tab on the top bar. Chose New Special Ruler from the drop-down menu. Click on the New Perspective Ruler (Two-point Perspective).

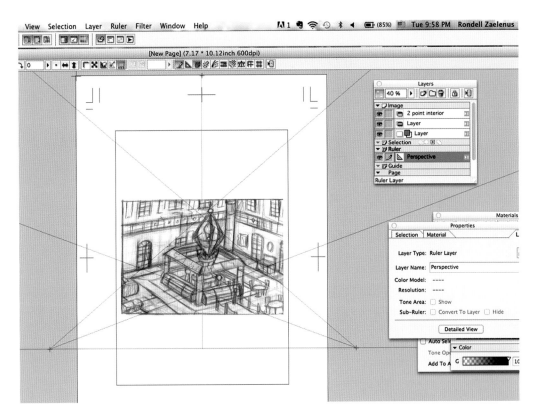

8. A horizon line with two points on it will appear on the drawing. Choose Object Selector in tool bar or hit the O key.

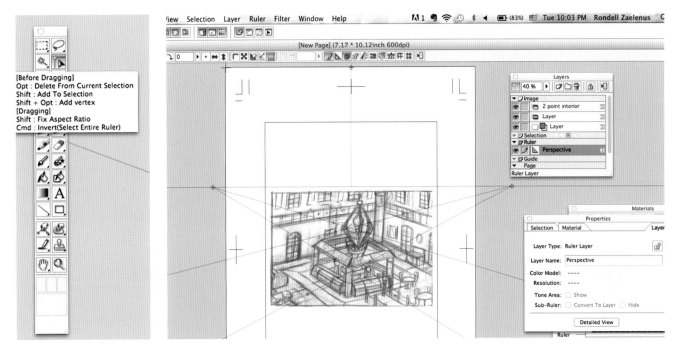

9. Use the Object Selector to adjust your horizon line.

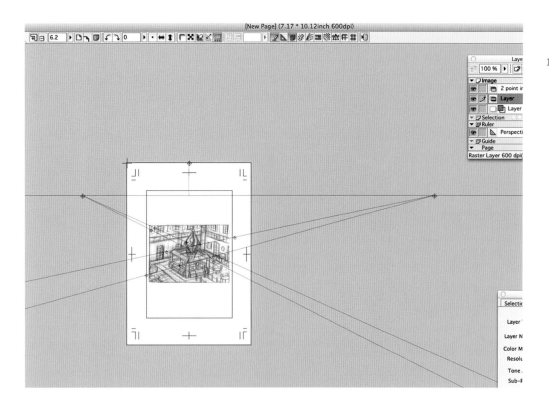

10. Move the vanishing points into place by clicking on them while holding down the shift key (you must hold shift to prevent the horizon line from moving while you adjust these points). They will turn from purple to red when they are selected. Make sure to click the background, returning the color of your point to purple, before moving to the other vanishing point. You can move the perspective lines that emanate from the vanishing points in the same way: click on them to move them and click the background to deselect them when you have them in the desired position.

11. Lock the perspective layer by clicking the Lock Layer icon in the Ruler Layer window. This will prevent you from moving it accidentally. If want to change the position of the vanishing points later to draw an object that is in a different position but still has its vanishing points along the same horizon line (remember chapter 3 on perspective?), just unlock the layer, select the object mover tool, hold down the shift key, and reposition the vanishing points. Then lock the layer again.

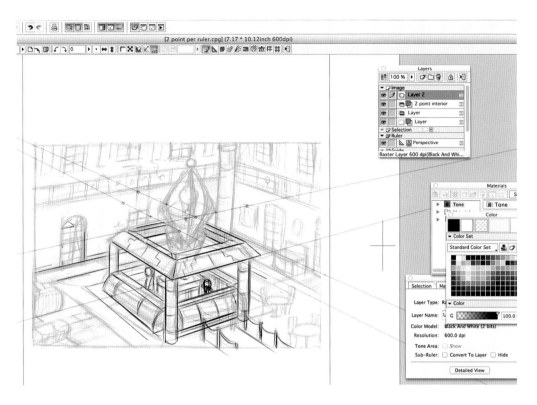

12. Create a new layer and label it 2-Point. You will use this layer for your perspective drawing.

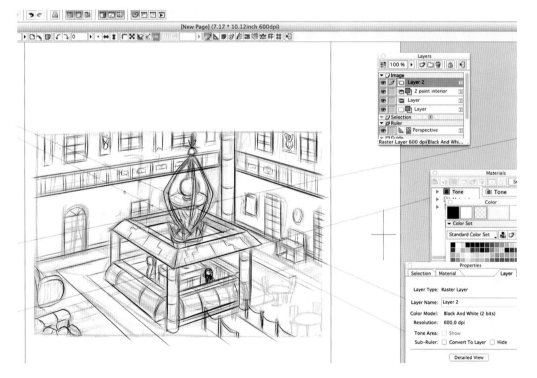

13. Making sure your new layer is selected, choose a Pen or Pencil tool, and begin drawing.

Using Manga Studio to Apply Screentone Patterns

The art program Manga Studio has hundreds of screentone patterns in its toolbox, and it's very easy to place and manipulate them. It's also fun. If you aren't familiar with Manga Studio, it's best to begin by using the Beginner's Assistant window. This function arranges all of the program's basic tools, pallets, and options on the right-hand side of the computer screen.

Note: for the purposes of this book, I have used Manga Studio version 4 for all examples.

TIP

Make sure that the screentones you choose don't create a moire pattern (an unintentional optical distortion) when the page you are working on is reduced and printed. The easiest way to make sure this doesn't happen is to reduce the page to the size it will be in your published comic and print it out. If it appears distorted, adjust the screentone and try again.

This image was sketched by hand, scanned, and inked digitally with Manga Studio. It's a nice clean drawing, but let's give it some patterns and texture.

1. Open Manga Studio and select the Beginner's Assistant: Window > Beginner's Assistant. Import your inked page. (Refer to page 130 for details.)

2. Use the Lasso tool to select an area where you'd like tone to be applied. If you are working with artwork that doesn't have any gaps in the inked lines (this is called a trapped area), you can use the Magic Wand tool.

3. Navigate to the right of the computer screen and click the Tone tab. Several screentone options will appear in the window when you select this tab. You can view them all or select them by category by clicking the pattern types. Spend a few minutes looking through them and select one you wish to use.

4. Click and drag your screentone over to the canvas. The tone will drop into the selected area. A new layer will be created automatically when you place a tone on your drawing. Thus, if you use three tones in an illustration, each will have its own layer.

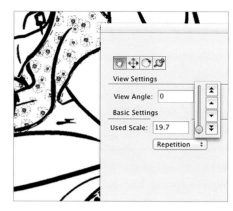

5. If you use Beginner's Assistant, a Properties window will appear when you place a new tone. (If you don't see this window, you can make it appear by selecting Window > Properties.) The Properties window allows you to modify the scale, the line density, the brightness and contrast, and the angle of the shapes used to create the tone.

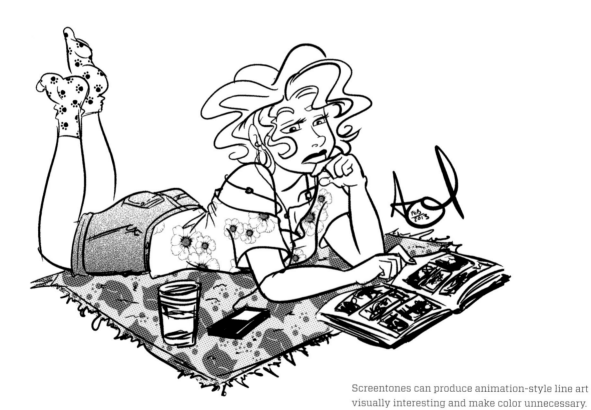

Screentones can produce animation-style line art visually interesting and make color unnecessary.

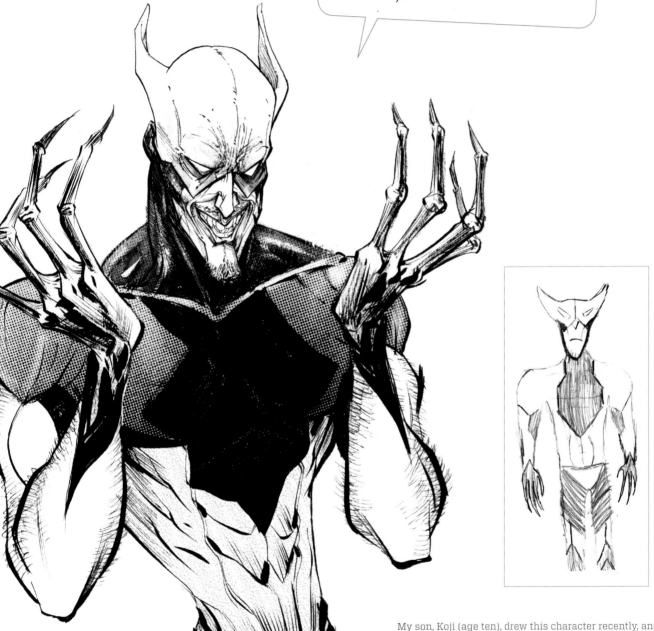

TIP

Since Manga Studio creates a new layer for every screentone you use, you can use other tools (Pen, Pencil, Brush, etc.) to apply that screentone anywhere you want on that layer.

My son, Koji (age ten), drew this character recently, and I drew my version of it for him. I inked it by using both brush and pen nib and then added digital tones.

CONCLUSION

Drawing comics is fun, but it's also a lot of work. Figure drawing, being able to construct objects and environments from your imagination, and having a true understanding of perspective all take time. You have to dedicate hours and hours to active learning.

In my experience, the key to success is setting small goals and pursuing them relentlessly. When you master one goal, name a new one and get started. If you take this approach, the day will come—sooner than you think—when you have more abilities in your possession than you have left to master. When you master all the necessary skills, creating comic art feels much more like play than work.

Make drawing a daily practice. You will become better, and faster if you devote an hour a day, every day, to drawing. The better you get, the more fun drawing becomes. You'll find that the hours fly by while you create worlds that only exist in your imagination.

Enjoy!

CREDITS

Note: Unless noted below, all art is by John Paul Lowe.

ii: Jorge Corona

iii: Maxwell Faria

v: Mike Wieringo and John Lowe,
 Pulse is © Chris Wozniak

vii: From top to bottom: Jarrett Williams,
 Becky Dreistadt, Jarrett Williams, and
 Jeremy Sorese

viii: Jeremy Sorese

xii: Becky Dreistadt

4: Ariela Kristantina

5: Eleanor Davis and Jerry Sorese

6: Tradd Moore

7: Jorge Corona

8–9: Alex Wilson

11: Jeeyon Kim

12 Ian McGuinty

14: Jeeyon Kim and Ian McGuinty

15: Zhenya Okun

17: Jeeyon Kim

18: Maxwell Faria

19: Jeremy Sorese

20–21: Jeremy Lawson

26: Lee Barrow

29: Ariela Kristantina

35: Jorge Corona

36: Jorge Corona

39: Jorge Corona

40: Tradd Moore

41: Becky Dreistadt

42–43: Jorge Corona

49: Amy Sherrier

50: Tradd Moore

51: Zhenya Oleum

52: Zhenya Okum

54: Ariela Kristantina

56–59: Ariela Kristantina

60–61: Jeeyon Kim

63: Alex Rivera

64: Ru Xu

65: Ariela Kristantina

66–67: Patric Reynolds

71: Robert Boucher

74: Mike Wieringo

79: Tradd Moore

83: Laura Neubert

86: Eleanor Davis

87: Drew Weing

88: Patric Reynolds

90–91: Jeeyon Kim

92: Eleanor Davis and Steve Beach

93: Jeeyon Kim

94: Drew Weing

95: Eleanor Davis

96: Chris Wright

97: Jeeyon Kim

104: Ariela Kristantina

105: John Paul Leon, *The Winter Man*

108: Mark Schultz

109: Drew Wieng

110: Kristian Donaldson

111: Yunfan Zhou

112–113: Liz Fleming

119: Jack Ciolli

120: Angael Davis

121: Kristian Donaldson

122–123: Jorge Corona

124: Amy Sherrier

130: Veeraya Kanchanobhas

136: Angael Davis

138: Angael Davis

139: Koji Lowe

140: Jarrett Williams

144: Tradd Moore

146–147: Tradd Moore

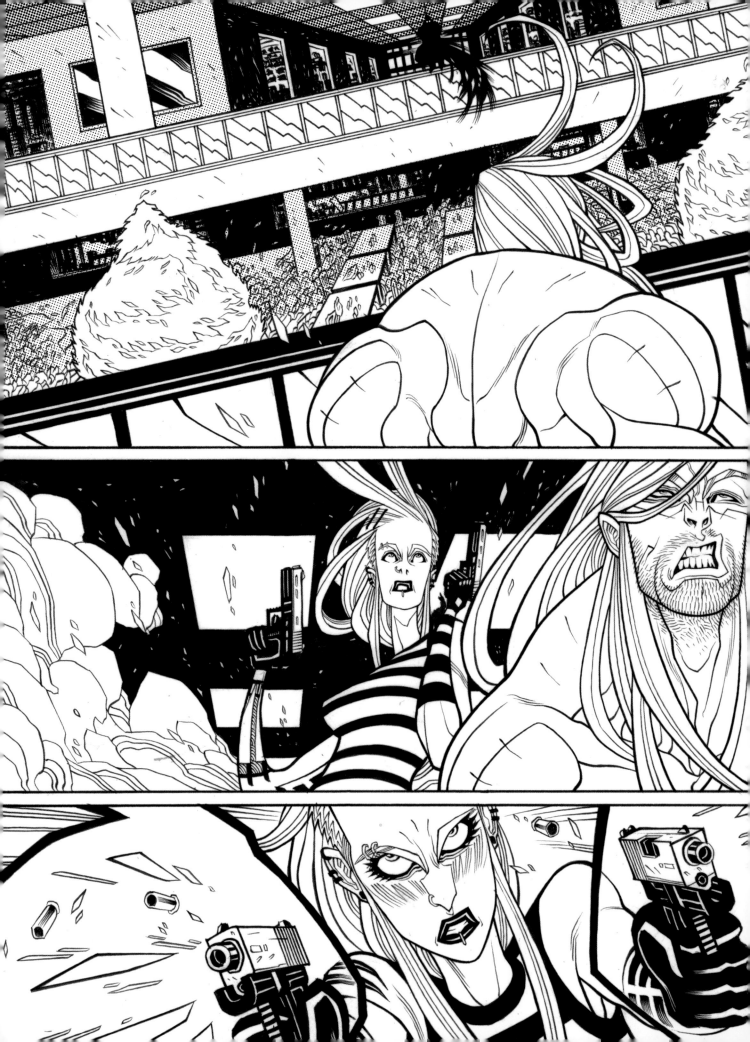

INDEX